The Brillo Box Archive

Interfaces: Studies in Visual Culture

Editors Mark J. Williams and Adrian W. B. Randolph, Dartmouth College

This series, sponsored by Dartmouth College Press, develops and promotes the study of visual culture from a variety of critical and methodological perspectives. Its impetus derives from the increasing importance of visual signs in everyday life, and from the rapid expansion of what are termed "new media." The broad cultural and social dynamics attendant to these developments present new challenges and opportunities across and within the disciplines. These have resulted in a trans-disciplinary fascination with all things visual, from "high" to "low," and from esoteric to popular. This series brings together approaches to visual culture—broadly conceived—that assess these dynamics critically and that break new ground in understanding their effects and implications.

The Brillo Box Archive

Aesthetics, Design, and Art

Michael J. Golec

DARTMOUTH COLLEGE PRESS

HANOVER, NEW HAMPSHIRE

PUBLISHED BY UNIVERSITY PRESS OF NEW ENGLAND

HANOVER AND LONDON

Dartmouth College Press

Published by University Press of New England,

One Court Street, Lebanon, NH 03766

www.upne.com

© 2008 by Dartmouth College Press

Printed in China

5 4 3 2 1

Use of the BRILLO® box, the BRILLO® trade dress and the BRILLO® print
ads is with the express written permission of Church & Dwight Co., Inc.,
Princeton, New Jersey. BRILLO is a registered trademark of Church &
Dwight Co., Inc.

Library of Congress Cataloging-in-Publication Data

Golec, Michael J.

 The Brillo box archive : aesthetics, design, and art / Michael J. Golec.

 p. cm. — (Interfaces, studies in visual culture)

 Includes bibliographical references and index.

 ISBN 978–1–58465–701–9 (pbk. : alk. paper)

 1. Warhol, Andy, 1928–1987 . Brillo boxes. 2. Harvey, James (James V.), 1929–1965. 3.
Danto, Arthur Coleman, 1924– —Aesthetics. 4. Aesthetics. I. Title.

 N6537.W28A65 2008

 700.92—dc22 2008007657

The sun is mirrored even in a coffee spoon.

—Sigfried Giedion, *Mechanization Takes Command:
A Contribution to Anonymous History* (1948)

CONTENTS

ACKNOWLEDGMENTS

One likes to think that writing is a solitary pursuit. Yet the production of a single text is a collaborative effort. I would like to extend my thanks to my editor, Richard Pult, who has been extremely helpful and patient throughout the process of writing, revising, and producing this work. I would also like to thank the two anonymous readers for the University Press of New England. Their questions and comments were crucial to my work. In the early stages of research, the people at the Archives Studies Center at the Andy Warhol Museum showed me many things I could never have found on my own. Also, thanks to Arthur Danto and Richard Wollheim for their time and wisdom. Since this work is taken from my dissertation, I am especially grateful to my adviser, Whitney Davis, for his guidance and encouragement. This work was made possible through the generous support of Mark Engelbrecht, Dean of the College of Design, Iowa State University, and Roger Baer, Chair of the Department of Art and Design, Iowa State University. Finally, I owe a great deal of thanks to my friends and colleagues Aron Vinegar, Michael Schreyach, and Ann Sobiech-Munson.

The Brillo Box Archive

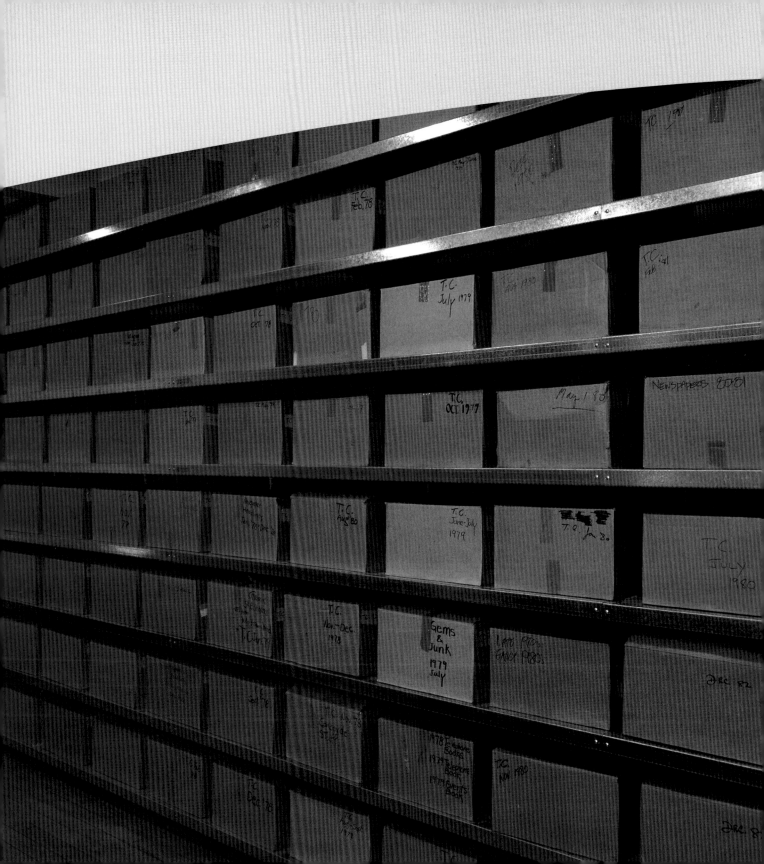

The Archive

In the Archives Study Center of the Andy Warhol Museum in Pittsburgh, Pennsylvania, there are 610 standard-size, brown cardboard boxes (fig. 1). They are the type of boxes that one might use to ship books or pots and pans. Andy Warhol's boxes were not intended for archival purposes. The artist (1928–1987) referred to the boxes as "Time Capsules." The archive began when Warhol randomly placed boxes around his workspace, or "factory"; he indiscriminately dumped anything and everything into them. The boxes remain extant, as does Warhol's odd system. Arranged according to when each box was sealed rather than to what each box holds, all 610 boxes are kept just as Warhol had left them. However, in a partial gesture to preserve archival conventions, the boxes are arranged in an orderly manner on industrial shelving in a back room of the center. Some boxes have been cataloged, but a fair number of them remain

1

*Fig. 1: Storage at Archives Study
Center of the Andy Warhol
Museum in Pittsburgh, PA.
Archives Study Center, Andy
Warhol Museum.*

unopened. There are boxes that have been extensively worked through. Opened and closed and opened, they bear the signs of use. Scholars who visit the Warhol Archives Study Center must search through everything because of the arbitrary arrangement of documents. The center's archivist could make a scholar's work easier by inventorying the entire contents of all 610 boxes and then arranging the contents according to the standard system. Rather than upset Warhol's random materials, some of the materials have been photocopied and stored in a file cabinet. These copies are an attempt at the creation of conventional archival order. But this is as far as the center is willing to go to accommodate scholars, who might go mad searching through Warhol's boxes.

Among all of the casually arranged stuff in the archives, Warhol's Time Capsule 12 stores a photograph of the commercial artist, graphic designer, and Abstract Expressionist painter James Harvey (1929–1965) holding a BRILLO® box in front of a large painting (fig. 2). Harvey designed the BRILLO® box package in 1961. The photograph signifies the nature of Harvey's split professional persona—designer by day for the industrial-design firm Stuart and Gunn and painter by night. The photograph was for an announcement for an exhibition of Harvey's paintings at the Gertrude Kasle gallery in Detroit. There exists a very similar photograph of Harvey and one of his large paintings—except, in this image, Harvey does not hold a BRILLO® box (fig. 3). (This photograph was reproduced in a May 13, 1964, *Time* article on Warhol and Harvey.) The distinction between the two images is crucial for an understanding of the status of Harvey's design activities, as compared to his conception of himself as an artist. In the photograph for the announcement, Harvey squats in front of a large-scale Abstract Expressionist–style painting. His hands hold a shipping carton for BRILLO® brand scrub pads. Striking a not-so-relaxed pose, Harvey's crouched presence connects these two objects: the painting and the box. The angle from which the photograph is taken seems to join the box to the painting, as if the two were attached and made a single artwork. The photograph uncomfortably stages what is not obvious: the one

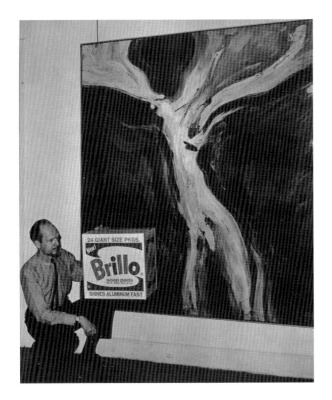

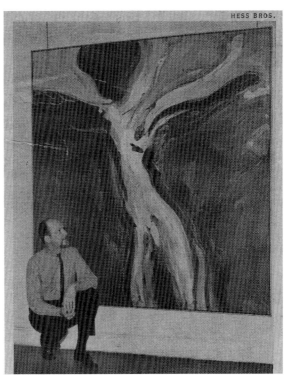

ABOVE LEFT: Fig. 2: BRILLO® Box
designer James Harvey with
painting and BRILLO® Box, 1964.
Archives Study Center, Andy
Warhol Museum. Use of the
BRILLO® trade dress and BRILLO®
print ads is with the express
written permission of Church &
Dwight Co., Inc., Princeton, New
Jersey. BRILLO® is a registered
trademark of Church & Dwight
Co., Inc.

ABOVE RIGHT: Fig. 3: BRILLO®
Box designer James Harvey with
painting, 1964. Archives Study
Center, Andy Warhol Museum.

object refers to the other object in the sense that we *see* something of Harvey's painting *in* his BRILLO® box design.

Andy Warhol's installation of stacks of *Brillo Box*es at the Stable Gallery in 1964 prompted Harvey to pose for this photograph (fig. 4). It is difficult to say whether or not there existed any direct causal relationship between Warhol's exhibition and the photograph of Harvey with his painting and BRILLO® box. It is unlikely, however, that Harvey would have thought to display his design work alongside his artwork if not for the Stable Gallery exhibition. No doubt, Warhol understood this to be the case, and this is why the photograph and other items pertaining to several *Brillo Box* as artwork controversies are stored in Warhol's official archive. When Harvey became aware of Warhol's exhibition and its many copies of his BRILLO® box, the artist/designer contemplated bringing

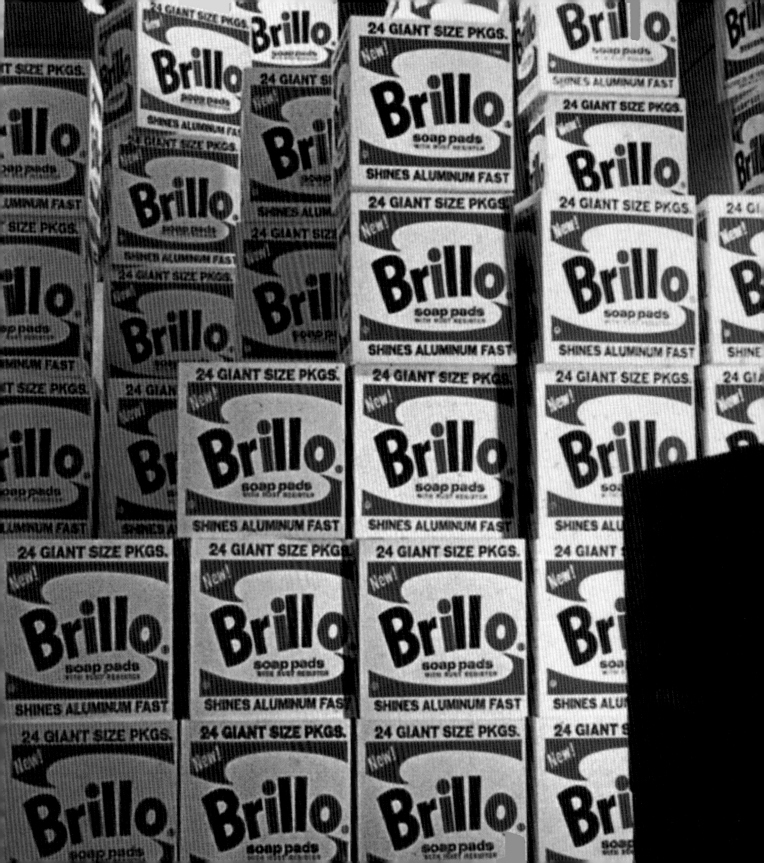

a lawsuit against the artist.[1] It was reported that, upon seeing Warhol's boxes, Harvey had to "choke back an impulse to start a paternity suit."[2] It is difficult to say how serious Harvey was. In a review of Warhol's show found in Time Capsule 17, the art critic Grace Glueck reports that "Jim Harvey felt slightly, (but not very) manqué."[3] He did not take action. Perhaps Harvey realized that he did not own the rights to his BRILLO® box design and therefore had no legal grounds to claim an infringement on his creative property. The Brillo Manufacturing Company (established in 1913) owned the BRILLO® brand and the BRILLO® box design. If anyone had a suit, it was the company, which had commissioned Stuart and Gunn to redesign the package. Perhaps Brillo did not litigate because the Stable Gallery exhibition was an opportunity for free publicity. While a lawsuit was nonstarter for Harvey, he decided to stake his claim in public in the form of a photograph that signifies his creative authority, regardless of the legalities.

Harvey was not alone in his disregard for Warhol's efforts to reproduce commercial objects for exhibition in the context of the artworld. A second event, documented in a newspaper clipping from Time Capsule 31, presents a more comprehensive sense of what was at stake in the contested status of Warhol's *Brillo Box*.[4] An exhibition of Warhol's work was scheduled to open on March 18, 1965, at the J. Morris International Gallery in Toronto, Ontario. Eighty of Warhol's box "sculptures" were held at the customs office. The boxes were subject to a tariff of 20 percent of estimated value, because they did not meet the Canadian Department of National Revenue's guidelines for the importation of artworks.[5] That is, Canadian officials did not see Warhol's *Brillo Box*es as artworks but rather as BRILLO® boxes (and thus subject to tariff). The department's guidelines stipulated that art galleries could import artworks duty-free. The National Gallery of Canada established and maintained criteria that determined whether objects were artworks or not. Following Tariff Item 695c, an expert in the field must issue a document that certifies artworks. In Warhol's case, the director of the National Gallery of Canada, Dr. Charles Comfort, declined the gallery's request for certification after reviewing a photograph of Warhol's boxes.[6]

Fig. 4: Andy Warhol's installation of Brillo Boxes at the Stable Gallery, 1964. Archives Study Center, Andy Warhol Museum. © 2007 Andy Warhol Foundation for the Visual Arts / ARS, New York.

Harvey's apparent wish to litigate and the Canadian government's refusal to grant Warhol's boxes the status of art objects are of a kind with the philosopher Arthur Danto's observations when he first entered Warhol's Stable Gallery exhibition. Like Harvey and Comfort, Danto (1924–), too, was struck by the near-identical resemblance between Warhol's *Brillo Box* and Harvey's BRILLO® box. For Danto, the encounter with Warhol's *Brillo Box* was productive. In his most recent account of the significance of Warhol's *Brillo Box*, Danto writes, "At the very least this *Brillo Box* raised the issue, at the most general philosophical level, of what its historical situation contributes to an object's status as art."[7] What was at stake for the philosopher —the ontology of art, or an investigation of the ways in which things belonging to categories are said to exist—held some significance for copyright law and the protection of intellectual property, as well as for government and the right to tax the importation of goods. In response, Danto wrote "The Artworld," an essay that explored the philosophical significance of Pop Art and of Warhol's exhibition of "indiscernibles." For Danto, Warhol's *Brillo Box* posed the question, How is it that we can distinguish an artwork from a mere object when the two are perceptually identical?

When I first encountered the photograph of Harvey with his BRILLO® box in the archive, I was reminded of the Austrian philosopher Ludwig Wittgenstein's discussion of the idea of "seeing-in." In a passage from his *Philosophical Investigations*, he describes an experience of cognitive awakening when perceiving something forgotten or something archived, as in stored away and retrieved at some later date. Such an experience is, as Wittgenstein explains, to notice an "aspect" of something.[8] Wittgenstein recounts, "I meet someone whom I have not seen for years; I see him clearly, but fail to know him. Suddenly I know him, I *see* the old face *in* the altered one."[9] Wittgenstein recognizes both the old and the new face simultaneously. It might be said the aged face archives the young face; the one necessarily results from the other. What remains of the young face is identified in the old face. The British philosopher Richard Wollheim took up Wittgenstein's very brief discussion of "seeing-in," describing it

as a special case of perception, where viewers can attend to both the material qualities of an object—primarily paintings, for Wollheim and its meaning or subject matter. We can see both at once. Describing the pre–Pop Art "Flag" paintings by Jasper Johns, Wollheim explains: "The tendency to think of our perception of these paintings as cases of seeing-in derives from the fact that we are aware of them as representations, with all that this involves (fig. 5). They are intended to be flags: flags are visible in them; and awareness of the pigmented features of the canvas is possible, and encouraged."[10] The "pigmented features" of Johns' flag painting are much like the aged features of the face in Wittgenstein's example. Also, the painting is quite literally an archive. Its "pigmented features" are torn bits of newspaper suspended in a tinted encaustic surface. Understood in this way, *Flag* (1955) stores information from the past; history is embedded in its surface. Fred Orton has characterized this particular moment in American history as one of "hysterical anti-Communism and un-Americanness," when the American flag was of particular importance to the citizens of the United States.[11] In no way does Orton claim that Johns's *Flag* was a chronicle of historical events. Rather, he argues that Johns made *Flag* "at a moment when national unity is perceived as both necessary and urgent."[12] Going one step further, a viewer can perceive unity and urgency in *Flag* as it stores the textual material or data of that particular historical moment of uncertainty and patriotism. Harvey's gesture toward his BRILLO® box is subtler than what either Wittgenstein sees in a face or what Wollheim sees in Johns's flag paintings. Yet it is no less intended to reveal an aspect or a feature of something too easily ignored or forgotten. Harvey meant his pose to point its viewers in a specific direction: to see his work of art—his creative spirit—in the design of the graphic motif on the box. Harvey's BRILLO® box archives the mediated yet authentic marks made by the artist. To see this particular BRILLO® box as an index of the role of the artist in a market economy is not as easy as it sounds, but it can be done.

The working thesis for this book-length essay is: if viewers see Harvey's painting in

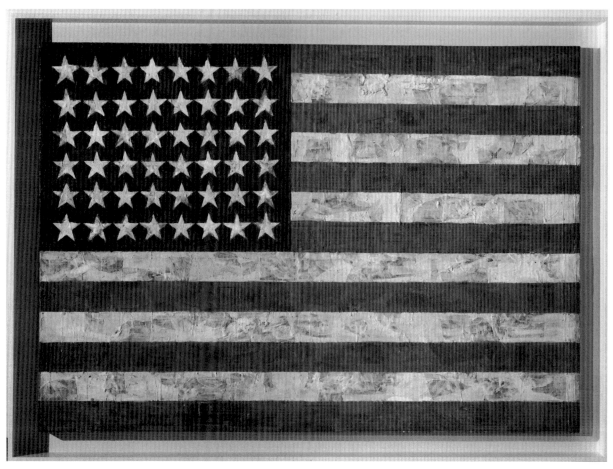

Fig. 5: Jasper Johns, Flag, 1955.
Museum of Modern Art, NYC. Art
© Jasper Johns/Licensed by VAGA,
New York, NY.

his design of the BRILLO® box, then they have encountered an instance of the archival or have come across something archived. Many things archive other things, just as there are many instances of seeing things in other things. The photograph of Harvey with his painting and box is exemplary of his BRILLO® box archive. In other words, the BRILLO® box that archives his painting is one instance of what I am calling the "Brillo box archive." Indeed, there are others, and this is what makes Harvey's case worthy of commentary. As I will discuss, Harvey's BRILLO® box archives or stores a historical moment when the critic Harold Rosenberg's idea of "action painting" in the artworld turned to "scrubbing action" in the domestic sphere and its visualization within the realm of advertising and marketing. This historical moment of disciplinary exchange—painting to designing—is an instance of the modern vernacular in American culture. Harvey's BRILLO® box is a cleaned-up or mediated version of what Rosenberg characterized as the "genuine act" of the "action painter."[13] The design of the BRILLO® box domesticated the example of Harvey's art by eliminating the rough edges of his painting and thereby transformed its "radical" potential into marketing potential.[14] This transformation took place not too long after the American art critic Clement Greenberg publicly worried about whether or not the United States was producing "art and literature of a high order" in his 1961 republication of his article "Avant-Garde and Kitsch" in *Art and Culture*.[15] Greenberg warned, "Kitsch's enormous profits are a source of temptation to the avant-garde itself."[16]

The photograph of Harvey without the BRILLO® box hides the fact that many artists—including Warhol—found themselves having to turn to the commercial sphere to survive—thus pursuing kitsch's "enormous" profits. In this picture, Harvey is an artist free of the mundane concerns of making a living and of getting by in an increasingly competitive artworld. In response to Warhol's Stable Gallery exhibition, Harvey's New York gallery—the Graham Gallery—sent out a press release that stated that Warhol had capitalized on the "starving artist" and his commercial work.[17] Such was the stigma of the artist having to work a day job that Danto went so far as to describe Harvey as a "failed

second-generation Abstract Expressionist who went into commercial art as a *pis aller* [last resort]."[18] In contrast to the photograph without the box and all that it endeavors to reify, the photograph of Harvey with the BRILLO® box admits to the realities of the life of an up-and-coming artist in New York in 1964—the artist sometimes has to take the *pis aller*. The presence of the BRILLO® box and its relation to the painting in the photograph of Harvey points to two additional archival events. The first event was Warhol's Stable Gallery exhibition, where he installed several hundred boxes, including his *Brillo Box* facsimiles. Again, this was the occasion that prompted Harvey's pose in the photograph. The second event was Danto's visit to the Stable Gallery and his encounter with Warhol's *Brillo Box*es as part of the larger exhibition. It was here that Danto first observed that the two objects—an art object and a design object—were indiscernible.[19] This is something that Harvey's photo with the BRILLO® box intended to argue against, despite the fact that we can see an artwork in the design work.

When observing that the photograph of Harvey with his BRILLO® box "points" to these other events, I refer to the way in which the staged photograph directs the attention of the viewer toward a set of historical circumstances and trans-formations. This, too, is an aspect of the archive. He shows that the gestural strokes that can be seen in his painting informed the precise graphic stripe emblazoned across his box, and that the free expression of his painting was transformed by the context of domestic commerce: messy painting transformed by clean scrubbing. In this case, the mechanical nature of his graphic design referenced the handwork of his painting. The chronologies of these events—painting then designing—were crucial to Harvey's sense of the proper "order of things." But when Warhol, who appropriated Harvey's BRILLO® box, and other Pop artists borrowed from the commercial sphere, they reversed this established order of fine art informing commercial art. The proper order of things maintained that the highbrow traditions of art should contribute to the forms of commercial art, but

the middlebrow traditions of commercial art should not influence the radical forms of fine art.

These were precisely the issues that were raised at the Metropolitan Museum of Art's "Symposium on Pop Art" in 1962. I will explore this event and its production of a discourse on the ontology of art in greater detail below, but it is enough to say here that the central theme of the symposium was that Pop Art was too close in appearance to the things in the world that it represented—commercial art or graphic design. The panelists addressed the rising anxiety that Pop artists, like Warhol, refused to make available to art viewers aesthetic experiences similar to those they might have had with orthodox modernist artworks. The symposium moderator, Peter Selz, for example, could discern the difference between Pop artworks and more traditional avant-garde artworks because he found Pop Art indistinguishable from common artifacts of popular culture. This problem would arise again in 1964.

As a matter of the history of 1964, an indistinct object was observably unchanged as it circulated through the disciplines of philosophy, design, and art and took on three distinct meanings commensurable with these distinct disciplines. One goal that this essay pursues is to make distinctions in practice. To make such distinctions is to remark on the differences among a philosophical practice of creating thought experiments, as Danto did in order to distinguish the "artworld" from the world of mere objects; a design practice, as ably exemplified by Harvey's BRILLO® box; and an art practice, as Warhol's *Brillo Box* critically demonstrated. Such a goal, however, has to contend with the imaginary and perceptual sameness of the Brillo box as it appeared in philosophy, design, and art in the early 1960s. What distinguishes each Brillo box from its near-identical counterparts is its manner of archiving an "epistemic culture" or the practice that constructs it as one of three objects.[20] By "practices" I mean the activities embedded in the context of an expert system, in domain-specific knowledge, and in knowledge-in-action. In other words, how do we know that Harvey's BRILLO® box is a design object and not an artwork or an illustration for

a philosophical problem? We know it is a design object because it was conceived within the knowledge-structuring practice of graphic design. The practice of aesthetics or, as it is also called, the philosophy of art and the practice of art construct altogether different Brillo boxes, ones that bear remarkable resemblances to Harvey's box. *The Brillo Box Archive* seeks to account for this constellation of concerns in aesthetics, design, and art.

In order to make the case for distinctions in practice, and not to merely make something of distinctions that bear on the archive, I borrow from Michel Foucault's notions of how discourses can form objects.[21] That is to say, discourses—relationships among statements, descriptions, propositions, evaluations, prescriptions, et cetera—determine how an object exists within a culture as it does. Of capital importance for Foucault is the "correlative formation of domains and objects and of the verifiable, falsifiable discourses that bear on them."[22] What can be verified or falsified is contingent not on a positivist approach to empirical observation but rather on the rules of a practice that "systematically form the objects of which they speak."[23] The "rules" established in and by a practice as an expert system or an example of an epistemic culture, as Foucault remarks, "define not the dumb existence of a reality, nor the canonical use of a vocabulary, but the ordering of objects."[24] The American philosopher and neopragmatist Richard Rorty compares Foucault's sense of the construction of objects in discourse to Wittgenstein's. When contending with Foucault's discourse as world making, Rorty goes so far as to suggest that Foucault's archaeology echoes Wittgenstein's anthropology: "One might simply take Foucault to be saying, in the manner of Wittgenstein, that we should remind our-selves of something we already know quite well: namely, that the way people talk [or write] can 'create objects,' in the sense that there are a lot of things which wouldn't exist unless people had come to talk [or write] in certain ways."[25] In both Wittgenstein and Foucault, the emphasis is on "forms of life"—and participating in specific lan-guage games in the former—and practices—or conditions of possibility in the latter—

that construct their objects. My goal is not to perform an analysis of either Wittgenstein or Foucault, nor is it my intention to map out their shared but distinctive positions. Rather, I mean to point out that the arguments for and against the Brillo box as an artwork, a mere box, or a philosophical thought experiment have affinities with Wittgenstein's "anthropology" and Foucault's "archaeology." In the case of Wittgenstein's anthropology, what is "built up" is the result of a "history of a practice."[26] And in the case of Foucault's archaeology, "discursive formations" are products of histories that survive as "archives."[27]

Wittgenstein's "history of practice" and Foucault's "archive" are alternative ways of saying "tradition." They are not alone in attending to the accretion of symbolic capital. Art history and visual and material culture studies are replete with examples that identify how objects are formed in the wake of traditions of making and interpreting (or practices) and how it is that traditions are located in existing objects as instances of the archive and of retrieval. Here, too, Wollheim is instructive. Wollheim persuasively argues that the "proper object of critical attention" is meaning as it is embedded in material.[28] I say "persuasively," because a similar proposal has been made in Jules Prown's essay "Mind in Matter." Prown maintains that the practice of material culture studies is fundamentally concerned "with the artifact as the embodiment of mental structures, or patterns of belief."[29] For both Wollheim and Prown, however informed by different intellectual traditions themselves, criticism is a manner of penetrating an object such that the critic retrieves intentions afforded by practice, tradition, and other disciplinary formations, all of which are stored in the object. The best-known examples are Aby Warburg and Erwin Panofsky's studies on how symbolic forms disclose meanings in culture. One can also cite immutability of form despite metamorphosis in the works of Henri Focillon; reproducibility in perception and as habit in Sigfried Giedion; replication and distribution in George Kubler; "free replication" and transmission in George Hersey;

tradition and allusion in Robert Venturi and Robert Venturi, Denise Scott Brown, and Steven Izenour; and replication and palimpsesting in Whitney Davis.[30]

These diverse methods of analysis all interrogate the flow of recurrent forms and meanings that link perception, cognition, and interpretation to what Bruno Latour regards as the "immutable mobility" of signification. According to Latour, graphic representation is immutable in its "optical constancy" and is mobile in its material form.[31] A graphic representation such as the Brillo box can circulate without alterations to its material qualities, which are constant. This does not mean, however, that its meanings are immutable. Universal constancy of meaning is untenable. Not too long before Danto encountered Warhol's *Brillo Box*, the American philosopher W. V. O. Quine wrote a devastating critique of traditional empirical models to ascertain meaning. Quine doubted whether a single sentence possesses meaning apart from its broader context of use—its "form of life," in Wittgenstein's terms, or its "discursive frame," in Foucault's terms. He observed that "there is a gulf between meaning and naming even in the case of a singular term which is genuinely a name of an object."[32] Citing the German mathematician Gottlob Frege's famous example centered on the phrases "Evening Star" and "Morning Star," where both phrases name the same object, Quine explained how the two names have two distinct senses even though they share the same referent.[33] He later expanded his observation and posited his theory of the "indeterminacy of radical translation." Quine's theory accounts for the fact that a sentence—for example, he considered "Ouch" to be a single-word sentence—has multiple meanings, and those meanings are determined by the context of use.[34] The same can be said for objects and their manifold significations. In fact, Danto paraphrased Quine when he declared that to refer to something as being "real" (Harvey's BRILLO® box) or as being "art" (Warhol's *Brillo Box*) when both are empirically identical was to peform a semantic function and not a verifiably perceptual function. Such a satisfactory performance, however, is predicated on conditions of historical framing or cultural context. To this, Latour might add: "It seems that reference is not simply the act of pointing or

a way of keeping, on the outside, some material guarantee for the truth of a statement; rather it is our way of keeping something constant through a series of transformations."[35] In the case of the Brillo box, the perceptual object remained constant, but the practices of design, of art, and of aesthetics were distinct. Thus the object was the same but transformed according to a practice. "Brillo box" is the name of an object in aesthetics, in design, and in art that means something different in each of its contexts of production.

The Brillo box archives sources specific to design, art, and aesthetics, while, at the same time, each box "live[s] by taking in each other's washing," to borrow a phrase from J. L. Austin.[36] While I argue that these practices are distinct and that they produce different objects, I also acknowledge that they are interrelated. They "live" off of one another in the sense that they are epistemically "interstitched."[37] For example, Danto's philosophical inquiry was informed by the collapse of traditional aesthetic criteria for differentiating artworks from everyday objects. By the time Danto crossed the threshold of the Stable Gallery, Pop artists had already blurred the line between the consumption ethic and the art ethic. To observe this boundary crossing assumes that such a line ever existed between aesthetics and consumption. Warhol was known for his inattention to the line between art and commercial design and for blurring boundaries when they were drawn in order to make claims for the superiority of pure art over commercial art. In this case, such an observation belies a conventional art historical approach to the study of artists and artworks—namely, an investigation of the social-historical construction of individual identities and intentionalities as revealed through artworks. My goal is to articulate that the boundaries between art, design, and aesthetics are discernible yet flexible and to track the movement of the Brillo box through different but related fields of production and interpretation in order to reveal that the object identified as "Brillo box" is not stable but rather only provisionally determined by its situation within three distinct historical and theoretical contexts. Each of the archival episodes that I account

for in this essay is representative of a particular discipline—philosophical aesthetics, graphic design, and visual art—and is subject to its traditions and conventions.

So, although Pop artists had for several years confused traditional boundaries, as Selz lamented during the "Symposium on Pop Art," Danto argued that the *Brillo Box* exemplified the *prima facie* philosophical problem of indiscernibility where two objects are perceived as identical—that began with Descartes and ended with Warhol. Danto's Brillo box archives the history of philosophical skepticism. And on account of the export of British ordinary-language philosophy (Austin's *How to Do Things with Words,* for example) to the United States and its attempts to detect the facts of the world in ordinary utterances, Danto, too, was sensitive to the way popular culture could influence the work of philosophy. Harvey's redesign of the Brillo box embodied the rationalization and modernization of domestic life in the United States. His BRILLO® box archives a history of visual representations of time- and labor-saving work, as first introduced by the early twentieth-century domestic adviser Christine Frederick and inflected across a range of domestic activities. The BRILLO® box design is both a record of and a result of the concept of efficiency as a guiding principle of postwar "household science." It is a diagram of modern organizational tendencies as they penetrated and structured the household. Viewed within the framework of this practice—a history of visual representations of efficiency—Harvey's design is in keeping with a complementary formation of the domestication of artistic activities. In other words, as demonstrated by his portrait with his BRILLO® box, Harvey understood that "action painting" could easily turn to "scrubbing action" and that radical expression could become normalized. Significantly, Warhol's appropriation of Harvey's BRILLO® box set it apart as what the artist praised as "a great modern thing." Warhol's *Brillo Box* archives the discord between viewing and acting, between pattern and culture, and between perception and identity in positivist (read "orthodox modernist") discourses on social organization and psychological norms that have dominated American

culture since the mid-1930s. Hence his observation that we can see "commercial art as real art and real art as commercial art."[38]

Warhol's observation is instructive. It informs the approach taken in this essay: to examine three instances—in commercial art or design, art, and, adding a third category, aesthetics—of the Brillo box as it materializes in the discourses that frame it and of the Brillo box as it makes material or archives those same discourses. In *The Brillo Box Archive*, the Brillo box becomes the central character in a narrative that accounts for three separate but related episodes in the life of an ordinary or common object—the triple life of the Brillo box. Still, the principal figure—the Brillo box—is a character without an identity—a shell, an empty signifier, or a "homeless" representation—except for qualities and histories supplied by the supporting cast: Danto, Harvey, and Warhol.[39] These three are the archivists; they point from their respective practices to the contents of the Brillo box so that we can see into their archives. Three episodes and their archives structure the narrative of the book: aesthetics, design, and art. Instead of organizing the essay into a chronology of events, where Harvey's BRILLO® box precipitates Warhol's *Brillo Box*, which precipitates Danto's Brillo box, I begin with Danto's encounter with Warhol's *Brillo Box*. This may seem counter to a historical account of the life of the Brillo box, but beginning with Danto and his entry into the Stable Gallery allows the reader to focus on the historical moment when the very sense of indiscernibility was acutely felt as a problem in aesthetics, design, and art. Also, by not chronologically ordering the essay, I maintain some of the randomness of the archive. After all, the events that I account for here occurred within a three-year span. Regardless of the order, in all three archival episodes multiple meanings are added to the Brillo box, depending on who is doing the archiving. The necessary order of the archive is generative in that its order makes meanings, and my reordering of these three archives is a kind of meta-archival act. If we must consider the archive in the abstract, we might say that the archive is repressive in its regulation of information. The

archivist practices, then, a succession of decisions that structure what is excluded and included in the archive. The list of contents offers choices after the archival fact. It is difficult for the researcher to discern the sequence of decisions that resulted in the archive. There are no maps. But there are gaps. Discontinuities, elisions, and edits disrupt the continuity of the archive. It is the difference between aesthetics, design, and art that make each Brillo box historically describable.

This is likewise the case, to a great extent, with the Warhol Archives Study Center. And, as I remarked above, the state of the archive was something of Warhol's doing. In *The Philosophy of Andy Warhol (From A to B and Back Again)*, the artist first spoke of his idea for a future archive made up of time capsules: "What you should do is get a box for a month, and drop everything in it and at the end of the month lock it up. Then date it and send it over to Jersey. You should try to keep track of it, but if you can't and you lose it, that's fine, because it's one less thing to think about, another load off your mind."[40] Perhaps this is the role of the archive: to take a load off the mind, and to suggest that whatever is forgotten is retrievable in one form or another.

Aesthetics

1

In April 1964, Arthur Danto walked into the Stable Gallery in New York City. There he saw an exhibition of Andy Warhol's silkscreen-on-plywood *Brillo, Campbell's, Heinz,* and *Del-Monte* boxes. Focusing exclusively on Warhol's *Brillo Boxes,* Danto later described the scene: "Mr. Andy Warhol, the Pop artist, displays facsimiles of Brillo Cartons, piled high, in neat stacks, as in the stockroom of the supermarket" (fig. 6).[1] Warhol's boxes, however, were not the kind that a stockperson would find in a storeroom of a supermarket in the early 1960s. But as Danto observed, Warhol's art boxes were identical to their nonart counterparts. This observation prompted Danto to write a career-starting essay on the topic, to present it as part of the 1964 symposium on "The Work of Art" at the sixty-first meeting of the American Philosophical

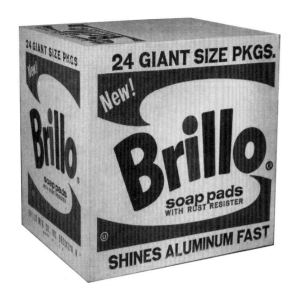

Fig. 6: Andy Warhol, Brillo Box, *1964. Archives Study Center, Andy Warhol Museum. © 2007 Andy Warhol Foundation for the Visual Arts / ARS, New York.*

Association, and then later that year to publish it in the *Journal of Philosophy.* In "The Artworld," Danto confronted the problem of the copy or, as he later put it, the philosophical problem of "indiscernibility." Danto argued that the difference between Warhol's *Brillo Box* and a BRILLO® box found in the super-market was a matter of interpretation rather than perception. All that he could tell from visually comparing the art box to the nonart box was that they were nearly identical or close enough to beg the question of indiscernibles. Beginning with this realization, Danto concluded that long-established traditions for judging whether or not certain objects were artworks were now obsolete. Of course, it was not enough that Danto simply asserted that the circumstances under which artworks were judged as such had radically changed. Indeed, in the face of an abrupt disavowal of long-dominant traditions and orthodoxies of art making and art criticism, the philosopher prescribed an "Artworld" theory of art to take the place of the two previous normative theories of art, which Danto identified as the "Imitation Theory" and the "Reality Theory." As Danto later recounted in the preface to his book *Philosophizing Art,* this observation led to his career-long engagement with Warhol, culminating in his most "explicit" statement on what Warhol's *Brillo Box* embodied: philosophy.[2]

Walking into the exhibition, Danto confronted the materialization of what he had learned in his college years from the example of the philosopher of symbolic logic C. I. Lewis: that language frames the useful knowledge gained from phenomenal experiences.[3] In other words, all that we can know of the world is all that we can say about it. Such an understanding of the relationship between the world and its description is in counterdistinction to a sense of a world that is out there, or present to us, to suit our faculties, but is not necessarily in opposition to

what Lewis took to be the eighteenth-century German philosopher Immanuel Kant's skeptical attitude.[4] For Lewis, who worked against what had become neo-Kantian conventions, the categories for constructing such a world are not fixed by our faculties alone but are subject to historical and cultural change. Danto took this observation two ways, both of which stood as crucial points in his argument for an "Artworld" theory of art. First, a common sense psychology that presumes that external objects produce internal processes is not always correct or cannot always explain in a one-to-one way how certain thoughts or imaginings can be directly attributed to a corresponding real-world thing. (Unicorns are the standard philosophical example.) And, second, the inverse is sometimes the case, where radically incommensurable objects—or worlds, like the "Artworld" of Warhol's *Brillo Box* and the supermarket world of the ordinary BRILLO® box—arise from two distinct descriptions or interpretations.[5]

Indeed, Danto understood that maintaining an empirical or a sharp and observable demarcation of boundaries between a universally understood "beautiful" and a subjectively understood "agreeable" had become increasingly difficult ever since Kant made the skeptical observation that we "speak of the beautiful as if beauty were a quality of the object."[6] For Kant, linguistic usage played a crucial role in an appeal to universal "beauty" such that there are differing sets of expectations regarding the objects of such descriptions.[7] The same might have been the case, then, for definite distinctions between artworlds and nonartworlds. Warhol's *Brillo Box*— along with Claes Oldenburg and Robert Rauschenberg's beds, Jasper Johns's flags, targets, and maps, Roy Lichtenstein's comic strips, and anything in the Bianchi Gallery's "American Supermarket" exhibition—challenged Danto to directly face this ontological difficulty.[8] The nagging question for Danto was this: When confronted with an object that was perceptually identical to another object of a seemingly different order—Warhol's *Brillo Box* and a mere BRILLO® box— could a descriptive account of one distinguish it from the other? This question

interested him both as an analytic philosopher and as an art critic; Warhol's *Brillo Box* prompted Danto to begin writing on art based on what he had learned as an analytic philosopher from Hume, Russell, Moore, Wittgenstein, Lewis, Austin, Quine, Thomas Kuhn, and Nelson Goodman.[9]

In this chapter, I will account for Danto's Brillo box and its archive of the shifting patterns of aesthetic evaluation. While it may be the case that, since the arrival of Warhol's *Brillo Box* in 1964, Danto has encouraged his readers to suspend visual perception when navigating the world of contemporary art, it was also the case that Danto took seriously the visual nature of Warhol's presentation of the philosophical problem of indiscernibles. As Gregg Horowitz and Tom Huhn have observed, an artwork need not take the visible or the visual for granted, but rather it "makes something visible—say, a spirit—that would otherwise be simply vaporous and ghostly."[10] This chapter makes sense of this seeming contradiction between Danto's disavowal of perception and his insistence on art as a form of Hegelian exemplification, where "spirit" is made visible or is embodied. Danto's "The Artworld" essay is a moment when he recognized that the eye could not anymore distinguish art from reality. Such a radical observation begs many questions: What was the critical-philosophical grounding for Danto's "Artworld" theory of art? What theories did it replace? And what new model for aesthetic judgments did it establish? One way to answer these questions is to examine the context of art criticism where experience and interpretation are contested. These were the discourses that directly bear the brunt of Danto's view of the inoperable optics of Warhol's *Brillo Box*.[11] What discourses did Danto challenge with his "The Artworld" essay? Were art critics engaged with the same issue of indiscernibility? And, if so, what did his essay contribute to the discussion? These questions sketch out the beginnings of an inventory of what we can see in Danto's Brillo box archive— an archive of perceptual skepticism, where the logic of realism or reality is reversed.

2

According to Danto, the realizations of critics and artists that artworks, rather than imitate real things, could be real things inaugurated "RT," or the "Reality Theory" of art. Artists who practiced within the framework of "RT" were "to be understood not as unsuccessfully imitating real forms but as successfully creating new ones, quite as real as the forms which the older art had been thought, in its best examples, to be credibly imitating."[12] The guiding principles of "IT," or the "Imitation Theory" of art, resulted in instances of representational verisimilitude or mimetic artworks. Danto explained that what was once considered a deficiency according to one theory could suddenly transform into a new criterion of judgment and be reborn as a positive attribute under the terms of a new theory of art. Danto referred to this shift as a "conceptual revolution" in the history of art. The shift from "IT" to "RT" was "not so much a revolution in taste as a theoretical revision of considerable proportions."[13] The revision responded, according to Danto, to artworks that did not abide by and were incompatible with "IT." At the time of this "revolution" or "revision," a critic could not judge Cézanne and Seurat's Post-Impressionist paintings according to how well they imitated the real world, because "IT" was not applicable to artworks that were intended to be real objects rather than imitations of objects. In the face of this dilemma, "RT" recouped the materiality of the world for art. Danto did not claim that artworks that had once been under the reign of "IT" and now subject to the constructive influence of "RT" were more material or real than they had been in the past. Rather, he argued that "[b]y means of this theory (RT), artworks re-entered the thick of things from which Socratic theory (IT) had wrought, they were at least no less real."[14] "RT" posited that artworks are real things and are not just mimetic representations of things; artworks and real things share the same material properties that the artwork, unlike real things, emphasizes by calling attention to its materiality.

Where the Post-Impressionist paintings of Cézanne and Seurat signaled the end

of "IT" and the beginning of "RT," Warhol's *Brillo Box* marked the demise of "RT" as a viable basis for the evaluation of artworks. In other words, the presence of Warhol's *Brillo Box* flipped the switch on "RT" and rendered its impact on the artworld outmoded. At the very least, the appearance of Warhol's *Brillo Box* suggested that the difference between artworks and ordinary objects was less perspicuous than had been previously thought under the guidance of "RT." The *Brillo Box* pushed the critical and descriptive boundaries of "RT," blurring the distinction between art and reality. It was at this point that a critical uncertainty developed because, as Danto observed, there existed an inherent problem in "RT": its criteria of judgment too closely matched the same criteria for judging real things as real. This observation exposed "RT" to potential errors that were now understood as misguided attempts to visually discern artworks from real things. Danto made this point clear when he later explained in an article that followed on the heels of "The Artworld":

> *Non-imitativeness becomes the criterion of art, the more artificial and the less imitative in consequence, the purer the art in question. But a fresh dilemma awaits at the other end of the inevitable route, namely that non-imitativeness is also the criterion of reality, so the more purely art things become, the closer they verge on reality, and pure art collapses into pure reality.*[15]

Warhol's *Brillo Box* precipitated the collapse of art into reality; it raised questions that "RT" could not answer; and, more important, it begged *the* perceptual skeptic's question that had always haunted "RT": "Can one have mistaken reality for reality?"[16] We make this mistake at the level of perception where the world feeds into our nerve receptors as small bundles of light rays. Danto understood that he could not now trust his visual sense to guide him at the extreme ends of "RT."

While Danto admitted that art of the twentieth century had already put a great deal of strain on "RT," it was Warhol's *Brillo Boxes* that dealt a deathblow to the theory. And as he later concluded, "The Warhol boxes, however, make even this alleged indefinability a problem, since they so totally resemble what by common consent are *not* art works and so, ironically, make the question of definition urgent."[17] Warhol's Stable Gallery exhibition acquainted Danto with this particular historical urgency. A change had occurred in art, and Danto acknowledged it as a seismic shift in the ontological grounds of artworks.

At this point, Danto's interest lay not in the actual artworks produced but in the critical theories that explained them. Yet he was not concerned with the critical theories of artists. He was less interested in what Seurat had to say about his work than he was in what Roger Fry had to say about it.[18] And it was, for Danto, a similar case with Warhol. Danto's lack of interest in the intentions of the artist is consistent with the criticism that the philosopher's account of Warhol's *Brillo Box* resulted in a theory mapped onto Warhol's artworks. Accordingly, Danto's interest in Warhol served the philosopher's theory of art rather than providing his readers with a greater understanding of Warhol's art itself.[19] Perhaps even more damning is the observation that Danto produced a philosophy of art to explain Warhol's *Brillo Box* even though Warhol had published his own philosophy—*The Philosophy of Andy Warhol (From A to B and Back Again)*.[20] While it was true that Danto had yet to revise his philosophy of art to accommodate Warhol's philosophy, historically speaking, however, Warhol had not yet published his book when Danto wrote "The Artworld." In this particular instance, Danto did not confront Warhol's intentions but rather dealt with the fact that not all aspects of the *Brillo Box* could be adequately explained by "RT"; hence a new theory, the "Artworld," and a new theorist, Danto.

Like "conceptual" revolutions in science, Danto intended the "Artworld" to render all previous theories of art obsolete.[21] The implicit analogy that Danto makes between scientific revolutions and revolutions in the art world had to do with the definition of

theory as a set of statements or principles intended to explain a set of facts and phenomena. While the question of definition of artworks apart from mere things had only just become urgent in the 1960s, as Danto knew well, the appearance of indiscernibles had long bothered philosophers and cultural critics alike, either within the context of a thought experiment, as in the case of René Descartes' "First Meditation" from 1641 or as an instance of an actual observable phenomenon in the world, as in Marcel Duchamp's *Fountain* from 1917. Danto organized his Brillo box archive beginning with Descartes' dream and the problem of indiscernibility as it applied to the dream state versus the state of being awake. He then tracked the problem of indiscernibles to Kant's criterion of moral conduct, to David Hume's thought experiments concerning identical worlds, to Alan Turing's comparison of artificial intelligence and human intelligence, to Bishop Berkeley's world with and without God, and finally to Marcel Duchamp's readymades—urinals, bottle racks, shovels, and bicycle wheels.[22] No doubt, it struck Danto that Warhol's Stable Gallery exhibition and his *Brillo Box*es took up this tradition of perceptual skepticism. On the one hand, Danto was of the mind that if, as modernist art theory had proposed, art had been searching for its own definition through a critical evaluation of its status as compared to other things in the world, then Warhol's *Brillo Box* had indeed achieved this goal. On the other hand, for Danto, Warhol's *Brillo Box* archived a tradition of phenomenological distrust that was not necessarily motivated by the historical development of art. In order to reconcile art's self-criticism and philosophy's self-reflexivity, Danto stated, "I believe it was Warhol's chief contribution to the history of art that he brought artistic practice to a level of philosophical self-consciousness never before attained."[23] It was, however, Danto's philosophical Brillo box and not Warhol's *Brillo Box* that cut the perceptual grounds away from art, in Danto's attempt to resolve the problem posed by perceptual skepticism.[24]

Danto's "Artworld" theory and its skeptical proviso developed from a key passage:

"To see something as art requires something the eye cannot decry [*sic*]—an atmosphere of artistic theory, a knowledge of the history of art: an artworld."[25] Danto's observation implied that the visual appearance of an artwork cannot count constitutively as anything other than being a suitable cue for a classification of the vast array of objects that happen to appeal to the visual sense but paradoxically are not defined by their visual appeal. If the difference was, for Danto, a matter of history and theory, then "to see it [*Brillo Box*] as part of the artworld, one must have mastered a good deal of artistic theory as well as a considerable amount of the history of recent New York painting."[26] And, in *The Transfiguration of the Commonplace*, the culmination of his aesthetics since 1964, Danto summed the "Artworld": "It only brings to consciousness the structures of art, which to be sure, required a certain historical development before the [Brillo-box-as-work-of-art] was possible."[27] Knowledge of art theory and recent art history gave *Brillo Box* the ontological distinction of being an artwork rather than being a mere object. Danto thought that the sources were locatable, that he could discern history and theory *in* the work of art. This bit of tautology can be understood in this way: Artworks exemplify the discourses that determine their status as artworks.

The relevance of the "Artworld" theory arose when modernism, "material aesthetics," and "RT" exhausted all possible descriptions of artworks and still could not articulate the distinguishing material qualities that separated them from mere real objects. Danto claimed that an "aesthetics of meaning" would take over the job of judging which objects were artworks and which objects were not.[28] He failed, however, to explain why modernism, "material aesthetics" and "RT" were not on par with an "aesthetics of meaning." We know, however, that the appearance of Warhol's *Brillo Box* ended realism—that is, modernism, "material aesthetics", or "RT"—as a way of defining the unique qualities of artworks compared to things in the world.

Danto conceived of this end along the lines of the end of modernism. He wrote, "Modernism came to an end when the dilemma recognized by [Clement] Greenberg

between works of art and mere real objects could not longer be articulated in visual terms, and when it became imperative to quit a materialist aesthetics in favor of an aesthetics of meaning."[29] Greenberg's consternation developed with his supposition that the avant-garde had vanished and that there were only artists who duplicated the "cheapest" sorts of things. This state of the artworld caused the critic some concern because, as he understood it, the avant-garde had kept culture "*moving.*" And, in order to continue the march of culture, the avant-garde artist maintained "the high level of his art by both narrowing and raising it to the expression of an absolute in which all relativities and contradictions would be either resolved or beside the point."[30] Danto's philosophical aesthetics were founded on exploring the questionable relationship between reality and vision—can we trust vision to tell us what is real and what is not?—that Pop artworks addressed. "RT" and modernism shared the "dilemma" that was the result of the creation of Pop Art: artworks that often were visually identical (it seemed) to "mere real objects." Danto's belief that realism ended was not a belief that realist artworks would cease to be made, underscoring a paradigm shift in the history of art. Danto's "Artworld" theory provided the necessary criteria for identifying the context in which the prominent features of artworks were contrasted with those of real things.

3

Danto drew from a variety of sources to marshal forth his critique of an empirical model for judging things to be art or not art. Of all the possible influences, both acknowledged and unacknowledged, Danto's key statement—"To see something as art . . ."—drew on a series of examples given by Ludwig Wittgenstein to demonstrate the problem of distinguishing between two materially and perceptually identical objects. The problem of distinguishing between two such objects was a key theme in a series of lectures and informal talks that Wittgenstein gave between 1933 and 1935.[31] Wittgenstein's example of the problem was a Necker cube (astonishingly similar to

Warhol's *Brillo Box*): "You could imagine the illustration appearing in several places in a book, a text book for instance."[32] The illustration always remains the same throughout Wittgenstein's hypothetical textbook. Yet at the same time, each appearance of the illustration is different throughout: "In the relevant text something different is in question every time: here a glass cube, there an inverted open box, there a wire frame of that shape, there three boards forming a solid angle. Each time the text supplies the interpretation of the illustration."[33] And each time the cube changes into a different object: "But we can also *see* the illustration now as one thing and now as another.—So we interpret it, and see it as we *interpret* it."[34] The text was crucial for Wittgenstein to *see* the illustration *as* a glass cube, *as* an inverted box, *as* a wire frame, or *as* three boards that form a solid angle.[35] Likewise, a text or a discourse that established certain possible interpretations was crucial, as Danto explained, for anyone to see Warhol's *Brillo Box* as an artwork and Harvey's BRILLO® box as a designed object. (As I described it above, Lewis's thoughts on world constructions were compatible with Wittgenstein's description of "seeing-as.") Not only was Danto's practice framed by a historical moment where the same object appeared in two seemingly unique realms of reception and use, but his reception of Warhol's Stable Gallery exhibition was likewise framed by a tradition of philosophical thought that privileged the interrogation of everyday potential misperceptions.

Interpreters of Wittgenstein describe this "seeing-as" as "aspectual perception."[36] Wittgenstein explained the phenomena as an "expression of a change of aspect," where there is an "expression of a new perception and at the same time of the perceptions being unchanged."[37] The same problem takes on a slightly different sense, though relevant to issues in art theory, in the "Brown Book" section of *The Blue and Brown Books*. Wittgenstein starts with a drawing of a face: "Now although the expression that seeing a drawing as a face is merely seeing strokes seems to point to some kind of addition of experiences, we certainly should not say that when we see the drawing as a face we also have the experience of seeing it as mere strokes and some other

experience besides."[38] Wittgenstein means that to see a drawing as a face is to have our perception of the strokes fall away. We do not see "mere strokes" and face. The material and perceptual qualities—the lines—of the drawing may have something to do with seeing it as a face, but it is our ability to recognize drawings as faces that facilitates the fading of the strokes.

Certainly, Danto's encounter with indiscernibles was hardly an everyday occurrence. He did not generally encounter BRILLO® boxes in the supermarket and wonder whether or not they were commercial packages or artworks. An accumulation of such doubts, without question, could be understood as a form of madness. Indeed, as has been apparent since Duchamp's infamous *Fountain*, a store-bought urinal that the artist, under the pseudonym "R. MUTT," submitted to the Society of Independent Artists exhibition in New York City in 1917, the physical environment of art institutions has framed objects in such a way that they can be seen as artworks.[39] The philosopher George Dickie, who followed Danto's thesis with his own institutional theory of art, took up such a view. According to Dickie, objects are artworks as a result of an institutional framework—the "Artworld." The "Artworld," which is made up of museums, art galleries, artists, curators, collectors, critics, and art historians, categorizes objects as artworks.[40] But despite his influence on Dickie and the codification of the institutional theory of art, Danto was after something subtler in his observations. In advance of Nelson Goodman's publication of *Languages of Art* (1968) and in anticipation of his own critique of Goodman's "semantic ideologies," Danto's "The Artworld" essay presented the idea that an object may be an artwork sometimes (under optimal circumstances that may or may not have anything to do with the physical environment of the gallery or museum) and not an artwork at other times (under a different set of circumstances).[41] As he wrote, "What in the end makes the difference between a Brillo box and a work of art consisting of a Brillo box is a certain theory of art. It is a theory that takes it up into the world of art, and keeps it from collapsing into the real

object which it is (in a sense of is other than that of artistic identification)."[42] Danto positioned Warhol's *Brillo Box* at the end of an "entire structure of debate which had defined the New York art scene," where a "whole new theory [of art] was called for other than the theories of realism, abstraction, and modernism."[43]

For Danto, the visual qualities that he claimed both Warhol's *Brillo Box* and the mere BRILLO® box share drop away, like the strokes of paint that constitute the face in Wittgenstein's example. Danto saw Warhol's *Brillo Box* as an artwork rather than as a BRILLO® box. The "text," as Wittgenstein said, that informed Danto's perception was art theory and art history. Danto saw Warhol's *Brillo Box* as an artwork because it fit into a system of meaning that was theoretically and historically appropriate to artworks as he understood them. Because the same system of meaning was not appropriate to commercial packing cartons, Danto could not *see* BRILLO® boxes *as* artworks (nor could he see Harvey as an artist).[44]

4

The idea that Pop Art was too close in appearance to the things in the world that it represented was *the* topic of discussion at the Museum of Modern Art's "Symposium on Pop Art," held on December 13, 1962. Peter Selz, moderator for the event, queried the symposium's panel of critics: Henry Geldzahler, Stanley Kunitz, Hilton Kramer, Leo Steinberg, and Dore Ashton. Selz asked them:

> *I think most of us always felt that one of the absolute necessities for anything to be a work of art was the aesthetic distance between art and the experience. Now, if any aesthetic distance is necessary for a work of art, is an aesthetic experience possible when we are confronted with something which is almost the object itself?*[45]

In the context of the symposium, Warhol was one of the few Pop artists whom Selz named specifically. Selz maintained that artworks court aesthetic experiences that fundamentally entail our viewing an artifact that transcends its mere *artifactuality*. In other words, the artwork must transform the artifact it happens to represent. For the most part, the panel participants—some with barely suppressed disdain, others with moderate distrust, and still others with restrained celebration—expressed their doubts about the aesthetic value of Pop Art. Pop artworks, for example, seemed to possess little if any of the depth of imagination or meaning that a critic like Kramer expected from all modern art. He stated, "Pop art does not tell us what it feels like to be living through the present moment of civilization—it is merely part of the evidence of that civilization."[46] Geldzahler, on the other hand, praised Warhol, arguing for a realist interpretation to validate the artist's work: "Is it not logical that art be made out of what we see?"[47] Geldzahler appealed to the radical directness of Warhol's and Pop Art's capacity for social observation. In this sense, he asserted, what we see is what there is to see. Claiming the middle ground, Steinberg judiciously honored the jarring character of Lichtenstein's enlarged benday-dot paintings: "when I saw these pictures by Lichtenstein, I had the sensation of entering immediately upon a third phase in twentieth-century painting."[48] Steinberg's "sensation" resulting from contact with Pop artworks said much about the aggressive address of these paintings and suggests that Pop as a style was less important to the ensuing debate than the quality of their experiential impact.

The debate that ensued among the critics during the symposium centered on an unspoken question: How real should artworks be? It seemed that there was a threshold, a tolerance for what might constitute art as a category of objects. If an artwork was not real enough, as Kramer defined Pop Art, then critics were left to deal with inauthentic expressions of culture. If an artwork was just real enough, as Geldzahler believed Pop artworks were, then critics confronted objective records of the world that they inhabit. If an artwork was too real, as Selz inferred, then

critics were likely to be deceived by the appearance of such objects. When Selz observed that Pop Art was "almost the object itself," he demonstrated a neo-Kantian orthodoxy that presumed that optimal aesthetic experiences required distance and disinterest.[49] No doubt, Pop Art was "repulsive in its realism" because it drew Selz too close to reality, to the stuff of us and of our world.[50] This was not a mere concern of the critic. It was not by chance that Steinberg, quoting Victor Hugo, referred positively to an affective quality of an artwork as causing a "shudder" in the viewer.[51]

There were those who lamented the loss of an artwork's affective qualities and an ensuing shudder that followed a confrontation with art. In *Eros and Civilization*, Herbert Marcuse worried about the transformation of what was once a "science of sensuousness" into a "science of art."[52] In its earliest formulations, he wrote, "[t]he discipline of aesthetics install[ed] the *order of sensuousness* as against the *order of reason*."[53] The result was that "[t]he philosophical history of the term aesthetic reflects the repressive treatment of the sensuous (and thereby 'corporeal') cognitive processes."[54] According to Marcuse, sensuousness is a way of being open to the world. "The nature of sensuousness," he said, "is 'receptivity,' cognition through being affected by given objects."[55] For Marcuse, orthodox aesthetics contributed to a broader affliction of alienation, where humans are not open to but closed off from the world. The rationalizing tendencies of contemporary culture supported deeply rooted repressions that estranged humans from them-selves. As instances of desublimation, artworks offer potential and potent ways out from under the burdens of rationalization, in their capacity to extend human sense and to extend or externalize the human psyche. In his 1957 essay "The Liberating Qualities of Avant-Garde Art," Meyer Schapiro attributed the loss of authenticity in art to a deskilling of the artist in ways that were comparable to the results of Frederick Winslow Taylor and Frank and Lillian Gilbreth's systemization of labor at the turn of the century. For Schapiro, the avant-garde in art was a panacea for the ills of industrial society and its relentless standardization of all things.

If freedom existed at all in postwar culture, then, as Schapiro understood the concept, the artist who "creates forms that will manifest his liberty" embodied it.[56] Such was the case where it was feared that a devalued role of the artist in society would domesticate him (rarely her) in the sense of restricting art to mere human utility under the forces of market capitalism.

Marcuse's and Schapiro's assessments also summed Danto's response to Warhol's *Brillo Box*es as an episode of the repression of the senses in the history of aesthetics. From Marcuse's perspective, one could argue that when confronting the problem of indiscernibility made material in Warhol's *Brillo Box*, Danto imposed his theoretical regime of the "artworld" onto Warhol's art. This was yet another installment of the "order of reason." In doing so, Danto sought to renounce an "order of sensuousness" in art by claiming an end to realism. At the same time, efforts were made to explore the possibility of a nonrepressive aesthetics that challenged the prevailing rationalism that transubstantiated experiences of receptivity into a series of delayed affective responses. Marcuse's emphasis on the sensuous in art—that is, art of and for the human senses—was taken up by two critics who were contemporaries of Danto.

In his essay "New Realism," the American poet and art critic John Ashbery addressed the sensuous/sensual qualities of artworks, qualities that the "Artworld" theory of art denied. Responding to the 1962 exhibition "The New Realism" at the Sidney Janis Gallery, Ashbery claimed that New Realist artworks, including Warhol's dance-diagram paintings and his Campbell soup-can paintings, "accumulate the electrodes of my feelings."[57] "New Realism" and "New Realists" were terms that described early Pop Art and Pop artists. Earlier in the century, the Sidney Janis Gallery was known for exhibiting New York Dada and the Abstract Expressionists. By the early 1960s, the gallery represented Tom Wesselmann and George Segal. In addition to representing new artists, the gallery organized the New Realist exhibition, which included artworks by Oyvind Fajhlstrom, Wesselmann, Oldenburg, Enrico Baj, Wayne

Thiebaud, Warhol, Lichtenstein, Jim Dine, Robert Indiana, and James Rosenquist. It was the group exhibition of these artworks that caused Ashbery to have feelings that were a direct result of the activation of the sensory-perceptual system —or "electrodes," as he put it. The poet considered the New Realist object to be a generator of sorts; it made something happen to him.

Ashbery's remarks were both stunning and suggestive in their reference to the physiology of the critic as the site of aesthetic experience. His use of the term "electrodes" to connote shock and to describe the body's capacity for conducting vital energy was reminiscent of nineteenth-century reflex-arc theories of stimulus-response action. Early nineteenth-century studies of the neural mechanisms underlying behavior defined the body as a complex "reflex" center for multiple mediations between the senses and the muscles. Experimenters relied on the metaphor of and the actual use of electricity to describe and measure responses to stimuli in human subjects.[58] Other critics to pinpoint the location of aesthetic experience were the American psychologist Henry Rutgers Marshall, who practiced "the science of pleasure,"[59] and the German cultural critic Walter Benjamin, who metaphorically referred to the critic as a "power station" who tracks the "energies" of artistic production.[60] Both Marshall's and Benjamin's criticisms were moves against neo-Kantian orthodoxy and its promotion of the disinterestedness of aesthetic experience. Both critics promoted the body as a presence, if not precedence, in aesthetics. Ashbery's critical assessment of the New Realists and his emphasis on nervous energy countered neo-Kantian critics such as Selz and their disdain for experiences that were merely the result of sensory gratification. For Ashbery, the body was a region of aesthetic knowledge in which both pleasurable and displeasurable energies are transferred from artworks. Ashbery's anti-Kantian stance on contemporary 1960s art suggested that sensory gratification most certainly produced feelings that were of an aesthetic sort.

It remains unclear whether or not Ashbery was familiar with debates for or

against the physio-aesthetics of criticism, but the poet revealed his interest in the idea that electricity was descriptively apropos of painting when he later recollected his experience with Warhol's *Blue Electric Chair* (1963), one in a series of paintings of car crashes, race riots, poisonings, and suicides that were exhibited in Paris at the Ileana Sonnabend Gallery in 1964 (fig. 7). When entering the gallery, visitors confronted *Pink Race Riot* (1963) and *Green Car Crash* (1963). Turning right and proceeding to the gallery's second room, visitors saw several more car-crash paintings and two *Tunafish Disaster* (1963) paintings. The two-panel *Blue Electric Chair* hung on the far wall. One panel displayed a series of repeated electric chairs, while the other was blank. Spanning floor to ceiling, the diptych appeared to be integrated into the interior architecture of the gallery. To the viewer facing the expanse of *Blue Electric Chair*, the painting was electric in its full-on visual assault. The monochrome blue background with a matrix like (some said "mindless")[61] repetition of a grainy photograph of the electric chair at Sing Sing prison shocked the viewer's ocular-nerve array.[62] Having worked his way through the gallery, Ashbery explained, "Andy Warhol leads us to a visible world. But, in doing this, his recent *tableaux macabres* present new obstacles for the eye. It's not so much that a glance can't take in the whole thing, but that a thorough visual analysis would present the same obstacles."[63]

It would seem that this was the "visible world" that Danto sought to suppress in his "Artworld" essay, but was it really? A closer analysis of the experience that Ashbery attributed to his encounters with Warhol's artworks suggests that his experiences were in kind with the real objects themselves. Therefore, "a thorough analysis" of Warhol's electric-chair paintings "would present the same obstacles" as electric chairs. It could have been that Ashbery's account was compatible with Nelson Goodman's notion of a "mode of metaphor" or, in other words, a manner of acting or doing.[64] If so, then Warhol's electric-chair paintings exemplified electrical shock for Ashbery—thus, the metaphor resided with the chair and not with the shock, because the picture possessed the optical qualities that rendered an assault on Ashbery's senses but did not possess

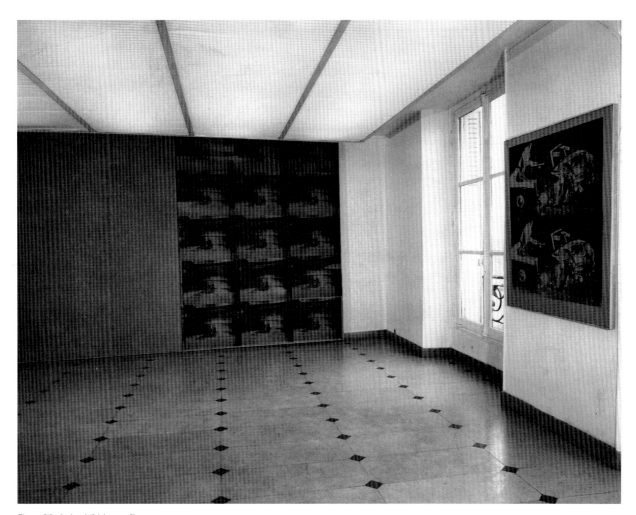

Fig. 7: Warhol exhibition at Ileana Sonnabend Gallery, Paris, 1964. Blue Electric Chair and Green Disaster Twice at Sonnabend Gallery, Paris, January 1964. Photo by Pierre Golendorf. Founding Collection, The Andy Warhol Museum, Pittsburgh.

an actual chair. The idea that Ashbery felt as if his body were in the electric chair in Warhol's electric-chair paintings had to do with the fact that no body (and nobody) occupied the electric chair in the paintings. In other words, Ashbery's body was outside of the picture—in front of it—placing the issue of intelligibility on the corporeal realities of the viewer and not only on what could be interpreted symbolically from the picture itself. The art historian David Summers has called this mode of metaphor "substitution." He has discussed this in terms of a phenomenology of "real metaphors" as instances of substitution—taking one thing for another—in this case, a painting of an electric chair for an electric chair.[65] Ashbery occupied the electric chair only metaphorically, in that Warhol's paintings made him feel *like* he was in the chair, and thus he confronted the same obstacle: death. For Ashbery, Warhol's electric-chair paintings allowed his body to sample what would normally ravage it. This was an instance of taking a "homeopathic dose"—the dispensation of something in a diluted form, in a practice that treats diseases by giving less-than-lethal doses of a remedy that would in healthy subjects make manifest symptoms similar to those of the disease.[66] While there certainly was no mistaking Warhol's electric-chair paintings for *mere* electric chairs, Ashbery's account presented the possibility of indiscernibility at the level of the senses. Thus, while the objects may not have been identical, feelings derived from an electric chair and Warhol's electric-chair paintings were the same. Confused feelings could lead to perceptual skepticism on par with the philosophical tradition that Danto assumed when confronting Warhol's *Brillo Box*es. Except, as Howard Caygill has argued, pleasure and displeasure distinguish objects—not as objects per se but in how objects affect the body, creating categories of pleasurable and displeasurable objects.[67] Thus, although Ashbery may have confronted the same obstacles, Warhol's paintings offered him the opportunity to distinguish between the electric chair and an electric chair painting at the level of the senses.

Taking up the critical challenge to sensory perception, the cultural critic, novelist,

playwright, and filmmaker Susan Sontag, in her essay "Against Interpretation," wrote, "Interpretation takes the sensory experience of the work of art for granted, and proceeds from there. This cannot be taken for granted now."[68] Sontag's essay responded to the same New Realist artworks that Ashbery discussed in terms of electricity and shock, only by 1964 the same objects were almost exclusively referred to as Pop Art. According to Sontag, the perceptual nature of New Realism/Pop Art was its "what it is, "its "rapid" momentum, and its "direct" address.[69] A common theme ran through each essay in Sontag's *Against Interpretation*, beginning with her title essay and ending with "One Culture and the New Sensibility."[70] In response to Madison Avenue marketing strategies, Sontag proposed that the cultural critic, confronted by the ever-escalating onslaught of mass media, must partake in the sensuous materiality of art—a most a paraphrase of Marcuse.[71] This was why interpretation could not be "taken for granted now." If contemporary art and advertising images shared qualities as demonstrated by Pop Art, then how could contemporary artists compete with the ever-growing proliferation of mass media, of which advertising was the most ubiquitous constituent? Sontag answered with the proposition that art heightened the experience of pleasure and displeasure and thereby raised the stakes of "the culturally oversaturated medium in which contemporary sensibility is schooled."[72] Somehow, according to Sontag, art stimulated the beholder in ways that exceeded the sensory attack of mass media. Art must appeal to and cultivate a sensibility that was open to its unique sensual and sensuous particularities. It caused its audience to feel in ways that were inaccessible to advertising in particular and mass media in general. So the difference between Pop Art and advertising was that the former was, or should be, more potent in its affective character.

Sontag's "Against Interpretation" targeted traditional hermeneutics, originally a method of liturgical exegesis but later the explanation or interpretation of all sorts of cultural artifacts. To Sontag, hermeneutics ignored the salient material features of an artwork and instead mined it for its assumed wealth of "content" or subject

matter. "In place of a hermeneutics," she prescribed "an erotics of art."[73] By "erotics," Sontag meant an appreciation for the sumptuous qualities of things, qualities that were beyond the scope of interpretation because of their palpable immediacy. Also, Sontag meant to draw on an aesthetic tradition that began with *A Philosophical Enquiry into the Origin of Our Ideas of the Sublime and the Beautiful*, in which Edmund Burke argued that our natural interest was always directed toward the pleasure of beholding while in the grip of sexual desire and attraction.[74] This was the tradition that Marcuse described as a "science of sensuousness." By "interpretation," she meant to refer to the "conscious act of the mind which illustrates a certain code."[75] A hermeneutics of art permitted the code—or as Wittgenstein might say, the text—to dictate a critic's response to an object and thus influence its ontological standing. Sontag considered both the code and the content that it sought to explicate "a hindrance, a nuisance, a subtle or not so subtle philistinism."[76] An erotics of art, on the other hand, allowed the sensual qualities of the object itself to dictate the critic's response to an artwork. Pop artists, for example, made "works of art whose surface is so unified and clean, whose momentum is so rapid, whose address is so direct that the work can be . . . just what it is," and Pop Art's clean and unified surfaces introduced "content so blatant, so 'what is,'" that it was "uninterpretable."[77] This was her response to advertising's dictum that the images and messages of advertising must be easily accessible and therefore interpretable (see "Archive 2"). Advertising's easy interpretation lent it the disciplining qualities of what Theodor Adorno and Max Horkheimer called the culture industry (see "Archive 3"). What seems odd or contradictory about Sontag's polemic is that, for her, art was more accessible at the level of the senses. This was, she thought, because artworks did not require anything of their beholders except pleasure.

By recommending that the critic reject interpretation, Sontag wanted to reinvigorate the potential sensory experience of artworks, to sharpen critics' sensitivity by eliminating interpretation's forestalling of the immediate, transparent qualities of

the "thing in itself."[78] As Sontag understood it, the immediacy of sensory experience resulted in responses that were beyond the interpretive causality of representation: "Even the simplest sensation is, in its totality, indescribable. Every work of art, therefore, needs to be understood not only as something rendered, but also as a certain handling of the ineffable."[79] In Sontag's view, art need not be incommensurable with objects that populate our world because, done erotically, it is of the world in all of its sensual particulars. Pop Art and contemporary abstract painting equally addressed the senses, according to Sontag. What mattered for Pop Art and Hard Edge Abstraction was a "pure, untranslatable, sensuous immediacy."[80]

Ashbery and Sontag were not alone in their investment in the sensual immediacy of contemporary visual art. Sonya Rudikoff concurred with Ashbery's assessment of the artworks found in the New Realists exhibition, and she anticipated Sontag's appeal to sensuous immediacy. In her review of the exhibition, Rudikoff wrote that "what we see is a curious, jagged, disjointed, and almost *abstract* use of an already destroyed realist image to construct occasions for sensation."[81] Rudikoff's "destroyed realist image" was the old view of realism, the ruins of an idea that realist artists merely record their contemporary surroundings. For her, those critics who followed an "avant-garde ideology which celebrates these artists as acute social critics" missed what was so penetratingly "new" in New Realism.[82] Like Ashbery's "electrodes," her greatest interest was New Realism's deliberate "concentration of visual energies."[83] According to Rudikoff, abstraction, in the broadest sense of the term, was the source of New Realism's manner of sensory concentration rather than its all-too-obvious and recognizable subject matter. For Ashbery, New Realism gave rise to "experiences" which exceed the objects, and they channel the "electrodes" of feelings. For Rudikoff, they were occasions for "sensation," and they focused "visual energies." Understood in a way commensurate with either critic's description, the potency of New Realism, and by extension Pop Art, lay with its activation of the viewer's sensorium.

Ellen Johnson's view supported Rudikoff's position on the "almost" abstract qualities of New Realism as a defining character of their affective potential. Johnson argued, "Much of the 'new realism' is far from realistic, dealing as it does with fantasy and the kind of illusion that our synthetic culture nourishes."[84] Johnson made two critical distinctions. First, she distinguished "new realism" from realistic artworks. She went so far as to use the term "abstract objectivists" to describe Roy Lichtenstein's and Andy Warhol's paintings. Second, rather than claim that New Realists, or "abstract objectivists," made copies of mass-marketed images for entertainment and consumption, Johnson suggested that New Realist paintings activated in the viewer feelings similar to those fostered by advertising, which itself was not known for accurate or real representations of contemporary life.[85] Sontag would have argued, in response to Johnson's claim that Pop, New Realism, and advertising shared affective qualities, that advertising made sense only within the ongoing rationalizing sources of contemporary social norms, which are the "codes" that dictate proper interpretations. In other words, advertising demanded interpretation as a prelude to instruction, whereas Sontag hoped that artworks could defy the sorts of framings that advertising required to establish the normative behavior of consumption.

5

Danto was immediately struck by the same qualities of the objects that Sontag and Ashbery had viewed positively and that Peter Selz, in his comments to the panel attending the "Symposium on Pop Art," had responded to negatively. On the one hand, Warhol's *Brillo Boxes* dispensed with the symbolic currency of BRILLO® boxes within a broad social and cultural network and emphasized their immediate sensual qualities. On the other hand, Warhol's *Brillo Boxes* were blatant copies of things in the world that themselves had no aesthetic value, which in turn was transferred to the artwork and its lack of aesthetic value. For Sontag, Ashbery, and

Selz, the question was, How real should an artwork be? For Sontag and Ashbery, the answer was that an artwork should be *really* real, shocking its viewers with jolts of optical/visual energy and energizing its viewers with a sensual immediacy. For Selz, the answer was that an artwork should not be *too* real; rather, it should transform reality and expose the metaphysical kernel of existence. From his position outlined in "The Artworld," Danto would consider Sontag's and Ashbery's view of New Realism and Pop Art and Selz's view of Pop Art's realism to be philosophically compatible in that their positions were all misguided by what they perceived visually. For example, in response to Sontag's claim that artworks' affective qualities had to exceed those of advertising, Danto would have pointed out that because Warhol's *Brillo Box* looked identical to a BRILLO® box, they shared the same potential for bringing pleasure to the viewer. Both required the proper frames or contexts of the commercial world and the artworld. From his point of view, none of the critics addressed the relevant issue raised by Pop artworks like Warhol's *Brillo Box.*

Where Sontag, Ashbery, and Selz collectively went wrong was in confusing art and reality at the level of perception and materiality. This was a confusion that Danto understood Warhol to have exploited in order to foreground the question of indiscernibility and ontological difference. For Danto, the question that Warhol's *Brillo Boxes* posed was of a different order:

> *Never mind that the Brillo box may not be good, much less great art. The impressive thing is that it is art at all. But if it is, why are not the indiscernible Brillo boxes that are in the stockroom? Or has the whole distinction between art and reality broken down?*[86]

It had. Danto's distinction between a real world and an artworld and between a "real object" and an artwork placed him squarely within the discourses on New Realism and Pop Art advanced by the "Symposium on Pop Art," Ashbery, Sontag,

and the rest. In response, Danto challenged realism as a viable paradigm for the visual arts at the level of sense perception and sensuous particularity or materiality. He denied that knowledge was the result of perception alone. Danto's denial inverted or reversed the logic of realism advanced by his contemporaries. Danto explained, "What Warhol taught us was that there is no way of telling the difference by looking."[87] The physiological discourses on New Realism and Pop Art claimed that artworks could furnish viewers knowledge through their perceptual receptivity and in the physiological responses of their bodies; viewers' interactions with artworks are transformative. Danto claimed the opposite and thus reversed the order: Viewers lend knowledge to objects and thus transform or, as Danto later said, "transfigure" them into artworks through the frames of history and theory.[88] At this stage in the history of art, according to Danto, artists were now free to make art anyway they liked, and all such objects could be judged art apart from traditional pre-scriptions. Warhol's *Brillo Box* marked this shift in that he made it possible to conceive of art apart from its previous perceptual grounding. According to Danto, it was only at this stage that "a philosophy of art like mine could be thought."[89] Therefore, Warhol's *Brillo Box archived* Danto's thought. But was there more to this thought than just an accounting of its place within the broader discourses on New Realism and Pop Art?

It is entirely possible that Danto never saw Warhol's *Brillo Box* in terms of its sensuous particularities but only in terms of its archival potential. Some readers of Danto might conclude that his preference can lead only to a deficient account of Warhol's *Brillo Box* in particular and all artworks in general. Such a criticism holds that Danto's philosophical thought experiment is impoverished for its lack of a perceptual object. In other words, the Brillo box that Danto constructs for philosophical aesthetics was devoid of the "vivacity" of Warhol's *Brillo Box*.[90] It is more than likely that he did acknowledge appearances at some point in his analysis but decided that such an acknowledgment led to an ontological deception.

Perceptual richness did not necessarily equal ontological certainty. The doubt that arose in the face of indiscernibility was, as Danto pointed out, the *prima facie* philosophical problem that began with Descartes and ostensibly ended with Warhol.[91] Warhol's *Brillo Box* exemplified this doubt, just as his electric-chair paintings exemplified shock. And both his boxes and electric chairs actively courted the imaginations of their respective viewers. In his *Meditations,* Descartes offered his reader a series of thought experiments in which examples of knowledge and belief were both thought to be secure but were undermined by counter examples that established "a ground for doubt." In the "First Meditation," he presented an example of a firm belief: "I am here, seated by the fire, wearing a [winter] dressing gown, holding this paper in my hands."[92] Descartes then attempted to upend his belief by suggesting that it was possible that he dreamed the fire, the gown, the paper, and his experience of the warmth of the fire and the texture of the paper. For Danto, Warhol's *Brillo Box*es offered the same narrative of belief and counter-belief as Descartes' thought experiment. Yet, the event was empirically verifiable in that any visitor to the Stable Gallery could have mistaken Warhol's *Brillo Box*es for those found in the storage area of a supermarket. The backroom context of the shipping cartons distinguished them from the front-room context of the gallery exhibition. Here, too, perception was not everything. Danto's theory suggests that Warhol's recontextualization—from backroom storage to front-room display—performed the ontological shift necessary to see the *Brillo Box* as an artwork rather than as a shipping carton. Yet the shift in context was not enough to distinguish the two. After all, both the spaces shared modes of production where the storage room and the gallery order their objects in ways that require labor—loading, transporting, unloading, inventorying, and arranging. Perhaps Warhol's real genius lay in his understanding that the installation of a gallery exhibition is very much like the delivery and storage of goods to a supermarket. While Danto did not explicitly

attend to the above issues, his "Artworld" essay implies that such issues were in play and that his theory could contend with these matters.

Danto's distrust of appearances was compatible with instances that Stanley Cavell has characterized as "skepticism, turning the existence of the external world into a problem."[93] The perceptual skeptic's dilemma is, however, his disconnection from the world. He does not allow himself to be touched by or to touch the world. Danto's perceptual skepticism, as it manifested itself in his reversal of the logic of realism, suggests that our connection to the world is not a connection in the literal sense of touching or being touched by the world but instead is in our linguistic and pictorial representation of the world. While Cavell has reminded us that Descartes' doubts concerning the veracity of the senses were reasonable, it may be "unreasonable to doubt that they [the senses] are ever reliable."[94] Danto's uncommon view, however, led him to an even greater appreciation of *Brillo Box*'s visual delights. Danto had to attend to the visual character of Warhol's installation first—the stark contrast of the bright-white *Brillo Box*es against the muted browns, reds, and greens of the *Campbell's, Heinz,* and *Del-Monte* boxes— before he could isolate the *Brillo Box* for philosophical interrogation. The problem of indiscernibility is first and foremost perceptually given. Cavell has suggested that our senses deliver the world to us. The condition of visual sensory perception "is our way of establishing a connection with the world: through viewing it, or having view of it."[95] It was through visual attentiveness that Danto formed his conviction that the ontological grounds for art had shifted. Quite literally, as Cavell might say, our view is established by where we stand *on* the world. A new world came into focus from where Danto stood in the Stable Gallery.

Danto placed Warhol's *Brillo Box* within the context of philosophy as the discipline attending to such problems as indiscernibles; thus, an archive of this new world— his Artworld—was in the making. A history of philosophical thought, of contending with the dilemma of misrecognition, produced the *Brillo Box* as an object that circulated and continues to circulate within philosophical aesthetics. In this sense,

Danto actually saw the *Brillo Box* *as* philosophy and argued that we can now see the history of philosophical thought *in* the *Brillo Box*. His archival strategy urged that we now consider the possibility that Warhol, like the philosophers, "showed that the difference [implied in the history of contending with indiscernibles], because after all philosophical, was not one that meets the eye."[96] It is this history of philosophical thought that made Warhol's *Brillo Box* possible and allowed for viewers to see it in Danto's Brillo box archive.

Danto's archive was also filled with the words of the many philosophers and critics paraphrased and quoted above. In this sense, it marked what Richard Rorty later called "a linguistic turn," or a turn away from "representational pictures of knowledge" in philosophy.[97] Perhaps we can construe Danto's archive as an instance of what the philosopher Ian Hacking has identified as "linguistic idealism" or "lingualism" and as a case of harboring the thought that nothing exists without language.[98] Or we could consider language—"almost the object itself," "evidence of that civilization," "shudder," "electrodes," "visible world," "rapid," "direct," "erotics of art," and "occasions for sensation"—to be a way of *wording* the artworld. Again, following C. I. Lewis, Danto observed that all we can know about the artworld is what we can say about it. It was the case that for Danto to guard against aesthetic misrecognition—of mistaking "reality for reality"—he had to bank on the world-making potential of language.[99] As Wittgenstein put it, "Philosophical problems arise when language goes on holiday."[100] It was also the case that such a guarded approach signaled a shift from an aesthetics of material to what Danto called "an aesthetics of meaning." Understood in this way, Danto's Brillo box not only archived a tradition of perceptual skepticism but also a new thought on how it is that we might approach all objects within a field of complex references so that we might properly recognize things in them. Thus, the same approach that Danto took to Warhol's *Brillo Box* in 1964 might also prove productive for the plain ol' everyday BRILLO® box and its aesthetics of meaning.

Design

1

"New! Brillo Soap Pads with Rust Resister. 24 Giant Size Pkgs. Shines Aluminum Fast."
These words were printed on the surface of a cardboard packing carton. The same text
was silk-screened across the surface of Andy Warhol's *Brillo Box*. Despite these "graphic
congruities," as Arthur Danto might have observed when he first confronted Warhol's
Brillo Box at the Stable Gallery in 1964, the two boxes are of distinctly different worlds.[1]
In other words, their words describe dissimilar worlds. If it were indeed the case that,
as Danto has said, "The language of art stands to ordinary discourse in a relationship
not unlike that in which artworks stand to real things," then what were the "ordinary"
discourses that stood to "real" BRILLO® boxes?[2] The ordinary can very often lead to
astonishment when language reveals what is sedimented in the mundane. Wonder is

Fig. 8: Brillo Box circa 1961. Use of the BRILLO® box, the BRILLO® trade dress and the BRILLO® print ads is with the express written permission of Church & Dwight Co., Inc., Princeton, New Jersey. BRILLO is a registered trademark of Church & Dwight Co., Inc.

what we stand to gain when we explore how discourses constructed objects—in this case, boxes—in the early 1960s. In the interest of the archive, I will begin by connecting these words—"New! Brillo Soap Pads with Rust Resister. 24 Giant Size Pkgs. Shines Aluminum Fast"—to real things.

Inside the BRILLO® box, there were more, smaller packages. These smaller boxes contained the actual products described on the shipping carton—BRILLO® brand soap pads with "rust resister" (fig. 8). The product had undergone minor innovations since the 1930s, when BRILLO® (Latin for "bright") had innovated the manufacture of steel-wool scrubbing pads with soap inside.[3] In 1961, "rust resister" constituted an improvement to an already established consumer product, prompting a redesign of the package. The industrial-design firm of Stuart and Gunn took on the redesign. Best known for its work with Bristol-Myers, A&P, Nestlé, and BRILLO®, the firm focused on the design of packaging for high-volume products generally found in supermarkets. Stuart and Gunn's niche was "design servicing," which entailed performing minor changes to existing package designs to add "new sales blurbs or premiums."[4] The primary goal of design servicing was to make consumers aware of an added value to a reputable brand. This meant that any adjustments to existing packages had to uphold and contribute to the reputation of the brand. In the case of BRILLO®, design servicing was also an opportunity for the firm and its client to make subtle but important changes to the overall design of the BRILLO® box. These changes created greater visibility for BRILLO® pads among its competitors (like SOS pads), thereby repositioning the product within the visually competitive environment of the supermarket. As is the case today, the words "New" and "Improved" punctuated 1960s

supermarket shelves and made visible the rhythms of marketing and advertising. The introduction of the "New" BRILLO® box in 1961 was one episode in the ongoing transformation of the visual culture of consumer products for the home in the United States.

This episode in the history of design has been eclipsed by a better known, albeit not unrelated, instance in the history of art. As I discussed in the previous chapter, in 1964 the American artist Andy Warhol exhibited several hundred boxes, some of which were his *Brillo Boxes* (1964), at the Stable Gallery in New York City. Scholars and critics have focused on Warhol's *Brillo Boxes* as examples of the hierarchies of taste-smashing strategies of 1960s artists—especially so-called Pop artists such as Warhol—who accomplished much in the way of introducing alternative criteria for aesthetic judgment.[5] Close ties between art and industry in the United States had long been established by the time James Harvey had applied his talents as a designer to the marketing of BRILLO® pads and by the time Warhol had taken up his appropriations.[6] The association caused some critics of art and culture a considerable amount of distress.[7] In all cases, Warhol's *Brillo Box* has obscured Harvey's BRILLO® box as an object of critical and historical interest. This has resulted in the production of a critical and scholarly bibliography on Warhol's *Brillo Box*, while there exists no writing on Harvey's BRILLO® box. In the end, the work of art continues to hide the work of design. This was where Danto entered the scene.

Perhaps this lacuna has something to do with still-present limitations of the traditions of art-historical scholarship and its influence on philosophies of art? The failure to attend to the significance of Harvey's design work, even if it were just an account to satisfy the question of Warhol's interest in the BRILLO® box as a cultural artifact, may have to do with the fact that Harvey was a struggling second-generation Abstract Expressionist who worked as a designer during the day.[8] As *Time* magazine reported, "At nights he [Harvey] works hard on muscular abstract paintings that show in Manhattan's Graham Gallery. But eight hours a day, to make a living, he labors as a commercial artist."[9] Within the framework of the traditions of art history, Harvey was

most likely considered a failed painter and not a successful designer, which suggests that he was, at best, a minor figure in the New York artworld.[10] In 1964, less-approving critics might have observed that Harvey's painting looked derivative of the long-established tropes of so-called action painters. Perhaps Harvey was, as William Rubin described, one of those "beginners and weaker painters" going through the motions (or actions) already established by a previous generation of painters.[11] Understood in this way, Harvey's career as a designer made it possible for art history to disregard his contribution in favor of Warhol's appropriations. The fact that Harvey found that he had to turn to the commercial sphere to survive may have contributed to the elision of his other contribution to American visual culture.[12]

Here I hope to rectify this situation through close observation of Harvey's BRILLO® box. Rather than focus on Harvey and risk the hagiography that still haunts art history, I will examine the BRILLO® box as a class of object—a shipping container—that was an instance of a negotiation between modernist design, which resulted from the rationalizing tendencies of the household-engineering movement, and the vernacular of American advertising and marketing. My interest is in how the BRILLO® box was situated within the competing principles and techniques (or *technics*) of universalism and functionalism of modernist design in the decades after the Second World War—what Danto has called "ordinary" discourses that were best expressed by the New Bauhaus in Chicago and its followers across the United States—and the populism and specificity of place and of the vernacular: in this case, the home. In so doing, it is my contention that the BRILLO® box archived these events. That is to say, we can see this history in Harvey's BRILLO® box archive if framed properly.

I will not go so far as to say that Harvey's BRILLO® box was an instance of or that it archived what Kenneth Frampton has identified as "critical regionalism." For Frampton, critical regionalism is a "strategy" implemented by an "*arrière-garde* [that] has the capacity to cultivate a resistant, identity-giving culture while at the same time having discreet discourse to universal technique."[13] Because Harvey used a red,

white, and blue palette for his design of the BRILLO® box, thus signifying the regional specificity of "Made in America," we can say that the design of the box hardly resisted dominant ideologies in the sense that Frampton has attributed to critical regionalism and its emphasis *on* place. I do not detect a strategy here, at least not in the strong sense of the term. Yet I am inclined to view culture, in a broad sense of socially and historically transmitted patterns of behavior, as consistent with having a strategy. I cannot say whether or not Harvey intended his BRILLO® box as a form of resistance. What I am after with this account of Harvey's BRILLO® box archive is the location and elucidation of a form of resistance that was internal to the design of the object and to the culture in which the object circulated. In other words, the perturbative vernacular of the BRILLO® box resisted the universalist tenets of modernist design. In this sense, design strategies and patterns of behavior were irreducibly intertwined. It would seem that, in the case of Harvey's BRILLO® box, the totalizing modernism of the New Bauhaus was at odds with the everyday artifacts of contemporary advertising and marketing and their emphasis on the home. Yet if I were of the mind that the two were apparently reconciled by the rationalizing tendencies of modern capital, whereby modernist design was tamed by commerce, then I would have to admit that such a reconciliation occurred with the product and its scrubbing action performed according to prescribed domestic duties, the result being an image of domestic bliss structured by such a cultural and social resolution.

Below, I will first discuss the "goods," as it were. I take Harvey's BRILLO® box as a "tangible proof" of modernist design of the postwar era and its negotiations with an American vernacular.[14] Perhaps it was not by chance that since the 1930s "modern" had been associated with BRILLO®.[15] Indeed, the term "modern" as it was used in advertising signified up-to-date, progressive, and/or advanced technologies to the consumer. Discussing the goods requires that I report on Harvey's design work and the observable adjustments that he made to the BRILLO® brand. Up until 1961, when Harvey redesigned the box, a distinctly vernacular visual vocabulary dictated the package design for the

BRILLO® pad. Harvey's design reconceived the brand in keeping with the tenets of modernist design of the postwar era, while he still maintained something of the brand's vernacular tradition. Second, I will account for the discourses on package design and the psychology of advertising in the United States that framed the BRILLO® box. In this context, the box demonstrated the visibility of household management, efficiency, and rationality in keeping with techniques for marketing commodities for the American home. The particulars of the American home were in large part informed by the "panoptics" or self-surveillance essential to the organization and management of the domestic sphere. Therefore, I will track down what the design historian Adrian Forty has identified as the "aesthetics of cleanliness" and its impact on the domestic sphere.[16] I will address these overlapping discourses in discussing domestic engineering and its relation to the consumption and use of products like BRILLO® pads. Roland Marchand has observed that advertising has produced images of personal accomplishment and "cautionary scenes of humiliations" to convince the consumer into thinking that she is incomplete or irresponsible for not using this or that product. On the face of it, these were all concerns with the domestic sphere, which had settled firmly within the vernacular, the popular, and the regional or national. But as Maiken Umbach and Bernd Hüppauf have recently observed, the vernacular cannot do without the modern, and the modern cannot do without the vernacular.[17] Harvey's BRILLO® box negotiated and archived a space between the particularized activities of the American home and the universalizing objectives of postwar modernist design.

2

Unlike Warhol, Harvey was trained in a fine-arts tradition—at the School of the Art Institute, Chicago—rather than in applied or commercial arts. While Harvey was in attendance in the late 1940s, the School of the Art Institute was invested in "very progressive trends in contemporary art"—namely, the New Bauhaus fusion of art and

industry intermixed with the romanticism of Abstract Expressionism.[18] The School of the Art Institute trained many up-and-coming expressionists with a feel for industry during and after the Second World War.[19] In fact, in 1948, students from the School of the Art Institute and the Institute of Design (formerly the New Bauhaus) had organized a joint exhibition, *Momentum*. Here the machine age vernacular of the old and New Bauhaus joined forces with the mechanics of expressionistic gesture to produce a collection of forward looking art and design. It is difficult to say whether or not Harvey was involved in this exhibition or any of the debates regarding the synthesis of art and industry in mid-century art education. We know, however, that once Harvey arrived in New York City, he was well prepared to take up both art and design.

Harvey was assigned to redesign the BRILLO® box in 1961 while working as a freelance designer for Stuart and Gunn. He redesigned the box so that it would act as a portable billboard or mobile advertisement of sorts. When reduced to a "conceptual minimum," the box possessed a twofold function: first, it contained products for easy transport and stacking, and, second, it acted as a framework or surface for graphic communication.[20] The primary goal of the package—either a single box or a stack of boxes—was to attract the consumer's attention and hold it for a period just long enough to deliver its message.

The previous package design (circa 1950s) was distinguished by two colors (red and black), an arced white swipe reversed out of red to signify cleaning action, and hand-drawn typography that was a mix of slab serif, sans serif, and a Gill Sans derived form (fig. 9). Harvey made several significant alterations to the existing design, changes that maintained the brand identification of the product, while at the same time he cleaned up its image. First, he removed the slab serifs on the "B," a subtle change but one that unified the typography across the entire package. The hand-lettered type—reminiscent of the German typographer Paul Renner's Futura Bold—gave the word "Brillo" and the brand a bouncy but rational profile. The previous version's slab-serif "B" and its nineteenth-century "Egyptian"

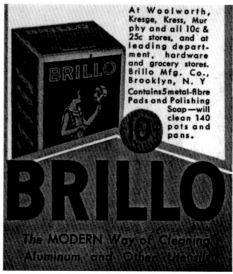

style was more in keeping with the brand's early-twentieth-century origins (fig. 10). An earlier package for the BRILLO® pad containing "special polishing soap" displayed a brittle sans-serif "BRILLO" in all capitals on an horizontal baseline. The curved baselines of the type treatments of the 1950s and 1961 packages required hand lettering, since the proportions of each letterform were more easily manipulated by hand. These finely tuned typographic treatments perceptually unified the logotypes. Harvey's deletion of the slab serifs resulted in a logotype that was thoroughly of its moment: USA 1961. Second, Harvey smoothed out the rough edges of the previous slightly curved, rough-edged, white swipe, which represented the product in action and cut across the box. The rough edges of the stripe indexed the grease-cutting power of the pad, and its rough edges were suitable for the kind of hard work that BRILLO® promised its pads could accomplish. Yet while scrubbing pots and pans was no easy task, it was understood that the pads lessened the labor. This made Harvey's streamlining adjustments appropriate to conveying the ease of using the BRILLO® pad. The later graphic mark referenced the actual shine of a pan

that made contact with the abrasive and the polishing surface of the pad, rather than emphasizing elbow grease. Harvey's "New!" design cleaned up the already existing image of cleaning action. Third, Harvey reconceived the color scheme of the box by introducing red, white, and blue to a hard-edged swipe. This created the perception of three floating planes, which lent the box a greater visual dynamic.

One possible explanation for the choice to use a red, white, and blue palette for the 1961 BRILLO® box, a choice that lent the brand the visual equivalent to "Made in America," was the fact that the company's direct competitor, the SOS pad, had literally positioned itself within the American imaginary: the "Kitchen Debate" between Soviet premier Nikita Khrushchev and American vice president Richard Nixon. The debate took place at the American National Exhibition, held in Moscow, on July 25, 1959. The status of the domestic sphere—that is, the "kitchen"—played a significant role there; it was an example of American political, technological, and economic superiority. Famously, Nixon had directed Khrushchev to a model kitchen from an average American home located in California. Once at the kitchen, the two political figures faced off. Nixon commented on how Americans were committed to "making life easier for their women." Khrushchev remarked that the Soviet Union did not possess such a "capitalist attitude towards women." Nixon then countered, "What we want to do is to make easier the life of our housewives."[21] Nixon's remark stressed the freedom of American citizens—freedom *from* drudgery and freedom *of* choice.[22] The focus of the debate frustrated Khrushchev, who preferred to discuss heavy machinery and not commercial goods.[23] Nixon's strategic examples of the domestic sphere and of the housewife—thus steering the debate away from armaments, heavy machinery, and rockets—emphasized the American standard of living.[24] The August 10, 1959, *Life* cover photograph of Patricia Nixon with her Soviet hostesses showed an American woman who embodied the exuberance of American consumer culture, as the vice president described it. Nixon's floral pattern dress, bracketed by the drab wear of the Soviets, her stylishly coiffed hair, and her

beatific smile, more resembled the middle-class satisfactions of the character June Cleaver from TV's *Leave It to Beaver* than the diplomatic seriousness of her station as the vice president's wife. This was what American democracy looked like. And, as a well-known photograph from the debate showed, laborsaving products like SOS scrub pads were central to an image of American freedom. Nixon evoked this image of order and efficiency when, at the end of the debate, he equated the happiness of American women with the effectiveness of American home technologies and tools.

With the SOS pad physically situated within this historical debate, the brand managers at BRILLO® must have searched for a way to reposition BRILLO® pads within the visual field of American consumption. (Unlike today, one could not buy this kind of product placement in the late 1950s.) The solution was to exploit the two spot colors used for the BRILLO® packaging. The combination of red and blue inks with the stock white cardboard box reproduced the three colors of the American flag. The reference was far from overt, yet the new color scheme aligned the BRILLO® pad with an already existing public symbol of unity. The combination of a national symbol that was already deeply embedded in American culture—the flag— and a consumer brand—the BRILLO® pad—created an immediately recognizable product. In the post–World War II era, advertising and politics in the United States traded on symbols and dreams.

3

On the paramount nature of a package's attention-grabbing capacity, the graphic designer Saul Bass wrote, "Careful design . . . can create a shipping carton which is not only an efficient container, but which also has the capacity to serve as a product reminder, a sales trigger, and a reinforcement of the general objectives of the product's visual merchandising pattern."[25] And, writing on package design for the professional journal *Industrial Design,* Ann Ferebee remarked that the criteria for

good package design was that it had to be "interesting, original—and memorable."[26] What, if any, were the objective goals of this criteria? In the late 1950s and early 1960s, consultants to the advertising and marketing industries established research facilities for measuring the affective character of package design. Firms like Lippincott and Margolies, Loewy/Smith, and Walter Landor utilized research as a significant component of the design process. The best-known application of design research methods was not practiced within a design firm; rather, it was practiced from the supply side. Under the direction of Albert Kner, the Container Corporation of America established its "Design Laboratory." Focusing on both projects directly related to sales and projects that were generated internally, Kner's lab applied a scientific method to the design of packages. The lab used spectrophotometers, visibility meters, and simulated shopping areas to test packages.[27] Consumer stimulation and apperception have long been integral to advertising's affective properties, as both Kner and Bass knew well. Bass also understood that a "product's visual merchandising pattern"—its schematic character—represented a potential for the emergence of behavioral patterns in keeping with the objectives of an advertisement. Research in package design tested whether or not it was possible to measure these behavioral patterns and, if possible, then applied the results in the supermarket.

According to the author of *The Psychology of Advertising*, Walter Dill Scott, "Any object or proposition will secure our attention that is in some way related to our hopes and fears, our ambitions and prejudices, our conduct or attitudes."[28] Thus, whatever the message, the box as a "sales trigger" had to appeal to the consumer's sense of his or her well-being. Psychology and advertising in the United States have been linked since the beginning of the twentieth century. The principal questions regarding how individuals think and act concerned both psychology and advertising.[29] In the case of psychology, efforts to aid individuals in achieving "normalcy" and social assimilation motivated studies and theories. In the case of advertising, questions were directed toward sales and how to study consumer behavior in order to anticipate or determine buying

habits. The goal was to use image and text in advertisements to stimulate consumption. Here, attempts were made to picture "normalcy" and social assimilation. Both advertising and psychology were invested in the study of the visual field as a basis for the establishment of eidetic images and apperceptions that were considered crucial to, on the one hand, psychical motivations for consumption and, on the other hand, the drive for acceptance and integration in the social sphere. The two were integrally related.

Scott was the foremost proponent of the application of psychology to advertising. He recommended:

> *In influencing the mind of another it is of importance to know in what terms he is thinking, so that the construction of the argument may be best adapted to his particular mental processes, for in this way he can be most easily influenced.*[30]

The key for Scott was for advertising to appeal to common experiences and to be grounded in everyday life. In Scott's terms, advertising was a medium of instruction, and its key component parts—text and image—were modes of training. In other words, aided by the methods of psychology, advertising disciplined its audience. Thus the lessons of psychology instructed the advertiser on how to exploit the suggestibility of consumers. The main challenge for advertisers, as Scott understood it, was to capture the public's attention and to get people to adopt new habits of mind and, therefore, new habits of consumption. As he put it, "It is very difficult to get the public to think along a new line, because they cannot connect the new fact with their previous experience, *i.e.*, they cannot apperceive it."[31] The goal, according to Scott's theory, was to introduce new information in ways that consumers could connect to past experiences. Advertising achieved this goal by exploiting clear, unambiguous, and familiar images and messages. (As I remarked in Archive I, this is what Susan Sontag defined as "the culturally oversaturated medium in which contemporary sensibility is

schooled.")[32] Harvey capitalized on this strategy when he introduced red, white, and blue into the BRILLO® brand. The three colors of the American flag were familiar to the American consumer. Also, it was thought that, under ideal circumstances, the advertising image's underlying schematic—its graphical structure—impressed itself on the consumer. Therefore, productive associations could be made, such as those among BRILLO® and "Made in America" and consumption and nationalism.

Scott's emphasis on the associative potential of apperception was deeply influenced by Wilhelm Wundt, whom he had studied with in Leipzig. Wundt's lab served as a model for the psychological study of the interconnectedness of human imagination, sense perception, and external stimuli.[33] Wundt's work took up the primacy of apperception in Freudian psychoanalysis and early-nineteenth-century studies of the neural mechanisms that defined the body as a complex "reflex" center for multiple connections between the senses and the muscles.[34] Often referred to as "associationist theory," Wundt's work was considered pioneering in the study of how sense impressions result first in eidetic images and second in ideational variations.[35] The eidetic character of apperception is manifest from the residue of experience; it is the after- or memory image of the sensory navigation of the physical world. It was thought that the schematic or the graphic image favored by advertisers could impact consumers, thus the lingering cogency of advertising. The observation of the behavior of subjects who responded to visual stimuli was codified and applied to the production of advertisements and packaging. In addition to Scott, Edward K. Strong and Daniel Starch studied the emotional effect of advertising layouts and compositions on Americans. Positivist and behaviorist approaches to advertising continued until well after World War II.

The structural implications of eidetic imagery and apperception, especially as both pertained to society, culture, and personality, were more fully theorized in Freudian ego psychology. The development of ego psychology in the United States had a profound impact on psychoanalytic thinking and its focus on the positive integrating

function of the ego. Thus, the adaptive character of ego formation and the integration of the subject into society became of central interest, beginning in the 1930s. Ego psychologists, as some neo-Freudians came to be known in the United States, focused on the vicissitudes of self-fulfillment and on the "healthy-minded."[36] Erik Erikson was probably the best-known ego psychologist in the post-Freud era. He proposed the crucial role of self-identity in the process of social integration. According to Erikson, ideal models or images established the basis for the formation of a positive self-identity—for example, illustrations of "good" and "bad" behavior found in children's books were models of socially acceptable and unacceptable conduct. Erikson focused his attention on the mutually beneficial relationship between internal and external representations and on taking images *into* the self as "conscience formation."[37] It was, however, the lesser-known neo-Freudians who came to the United States who were more devoted to role of the physiology of perception in the development of subjectivity and self-identity.

Expanding on Sigmund Freud's adaptive phylogenetics of subjectivity, the Viennese neurologist and psychoanalyst Paul Schilder formulated his theory of the "image" of the body in ego formation, emphasizing the physiological basis for "body image."[38] Focusing on the study of the body image and its impact on social psychology, Schilder proposed that we "experience" our body-image and the body-images of others.[39] Crucial to this view was Schilder's emphasis on the limits of our perceptual and physiological capacities to experience our bodies and the bodies of others. Three years after having taken residence at the Psychiatric Division of Bellevue Hospital in New York, Schilder delivered "The Soma-Psyche in Psychiatry and Social Psychology" to the Massachusetts Psychiatric Association. In his paper, Schilder claimed, "If in a picture of a body we were to mark the zones which are prominent in the body image of a particular personality, we would find the emotional tendencies and striving of the individual reflected in the picture."[40] Schilder's attentiveness to the mapping of the body was indicative of efforts to establish psychoanalysis as an

empirical science subject to meticulous observation and indefatigable verification.

Of all of the European émigrés who followed Freud, the Viennese ego psychologist Heinz Hartmann was at the forefront of the "scientization" of psychoanalysis in the United States. His particular approach to analysis was rooted in Vienna Circle principles of observation and verification.[41] Hartmann's efforts to rethink psychoanalysis into a science coincided with an expansion of the field of psychoanalysis and a rise of its public profile in the United States.[42] Hartmann's methods of empirical study of psychical states and socialization were especially appealing to both academic experimental psychology and the social sciences. The *American Journal of Sociology* praised Hartmann for transforming "psychoanalytic theory into a general psychological theory, permitting linkage with other behavioral sciences."[43] This "linkage" was especially useful to advertising. Joined by Ernst Kris and Rudolph Lowenstein, Hartmann devoted his attention to aiding ego development toward better integration in the social environment. Gestalt psychology partially influenced the environmental approach of ego psychology. Schilder, for one, admitted that "[o]ne cannot separate situation and instincts."[44] Furthermore, Schilder applied the term "integration" in a Gestalt-like manner when he spoke of the role that adaptation played in the development of "psychic patterns."[45] Some years after Schilder's allusion to Gestalt, Hartmann defined "adaptation" in similar terms. He claimed that the ego's vigor was predicated on the capacity of the subject to adapt or "fit" into an environment. He then added an observation that adaptation implied a "future condition."[46] Importantly, Hartmann outlined the evolutionary potential for action in the world, emphasizing the dual constitutive nature of biophysiology and ego psychology. Physical health and psychic health were synchronized. He claimed, "Man's existing relation to the environment codetermines which of the reactions he is capable of will be used in this process, and also which of the reactions used will predominate."[47] Adaptation, according to Hartmann, was a defense against irrational drives and supported the subject in his or her grip on reality. Order was the name

of the game. Any tendency toward disorder, according to Hartmann, was symptomatic of "regressive adaptation."[48] Increasingly, the period of postwar conservatism in the United States supported Hartmann's inclusive definitions of order and reality and place in society. In this context, Hartmann underscored the adaptation of the subject to the norms of postwar society. Certainly, as Harvey's BRILLO® box made clear, patriotism and consumption were irreducibly connected as normative behaviors.

Increased attempts to reformulate psychology into a science and make it relevant to the strictures of American society corresponded with systematic and positivist approaches in design theory and pedagogy in the United States in ways that were pertinent to the design of packages.[49] For a generation of postwar designers, the publications of the Hungarian-born New Bauhaus instructor Gyorgy Kepes codified and put into circulation the interests present in the psychology of advertising. In his extremely influential book, *Language of Vision: Painting, Photography, Advertising-Design*, Kepes introduced Americans to advanced theories of perception, signification, and representation.[50] Kepes proposed an interrelation between the senses and their stimulation by objects. He committed himself to the idea that universal visual comprehension was predicated on the signifying potential of advertising and that design bound representations *of* the world *to* experiences of the world. Advertising realized this process of binding when it reconfigured the world into a vision comparable to the hopes and dreams of consumers. Reconfiguration or "reintegration," as Kepes, echoing Schilder et al., defined this process, was a synthesis of the "dynamic experience" of perception and symbolic meaning.[51]

While Kepes never cited Walter Dill Scott, his notion of reintegration was compatible with Scott's emphasis on association through the schema structure of eidetic images and apperception. And while Kepes himself was not directly influenced by ego psychology, he was certainly sympathetic to the ongoing search for normalcy and social-emotional equilibrium in the field, as he understood both ideals to have had a substantial bearing on art and design. For example, the Viennese

psychoanalyst Felix Deutsch contributed "Body, Mind, and Art" to Kepes's *Visual Art Today*. A colleague of Hartmann et al., Deutsch rehearsed the main concepts of image integration in ego psychology.[52] According to Deutsch, the visual arts (commercial art and design included) attempt to recover lost realities that are constructed from past pleasures and pains, either real or imaginary.[53] And, supporting the physiological spectrum of Kepes's theory of reintegration, Ernst Gombrich contributed "On Physiognomic Perception" to the same book. Undertaking an explanation of the affective character of visual artworks, Gombrich wrote, "What we call the 'expressive' character of sounds, colors or shapes, is after all nothing else but this capacity to evoke 'physiognomic' reactions."[54] He then referred the reader to his "forthcoming" *Art and Illusion*, a book on the psychology of representation. Gombrich made a distinction, pertinent to the parallel positivisms in psychoanalysis and art theory, between a primary schema that is perceptual and/or cognitive and a secondary schema that is diagrammatic, pictorial, and/or illusionistic. Citing Hartmann, Gombrich underscored the world-structuring potential of cognitive/perceptual resources.[55] No doubt, for Gombrich as well as Kepes, it was Hartmann's emphasis on the *eidetic* character of perception and its potential for framing actions in the world that was suggestive of the projected iterations provided by schema.[56]

Modernist design in the service of advertising and marketing was not a matter of replicating a prescribed "Modern" style. Rather, the identifiable style of modernist design was its material expression of the organizational and rationalizing tendencies of modernity, best exemplified in Kepes's interest in taking up positivist psychology. There were certainly other instances of this tendency. The Container Corporation of America's "Design Lab" was a product of the positivist conceits of design and advertising as they were discussed in Kepes's texts. By measuring consumer responsiveness to the visual and material phenomena of packaging, Kner and his associates (designers like Ralph Eckerstrom and John Massey) endeavored to organize the subjective experience of the consumer to meet American social

norms. Kepes's *Language of Vision* and his other writings provided designers with a theory and a methodology for taking up the positivist underpinnings of modernist advertising and design as styles or as forms of life. He wrote, "Visual language thus must absorb the dynamic idioms of the visual imagery to mobilize the creative imagination for positive social action, and to direct it toward positive social goals."[57] Later, Kepes added, "A visual control of the environment, guided by . . . healthy vision would give man not only a healthier, sounder physical setting, but also what is as important, it would increase his stature."[58] The organization of a social organism produced a healthy human organism, according to Kepes, and the attainment of "healthy vision" was the key to attaining this goal. For Kepes, advertising offered such an opportunity:

> *If social conditions allow advertising to serve messages that are justified in the deepest and broadest social sense, advertising art could contribute effectively in preparing the way for a positive popular art, an art reaching everybody and understood by everyone.*[59]

Kepes proposed that a "positive popular art" was a baseline norm for constructing socially acceptable behavior, in the broadest sense an empirically verifiable aspect of human action. Kepes anticipated that his ideas of cultural progress and universal social norms would exert themselves in the home and in the array of products designed for domestic consumption. But, like Greenberg, Kepes was adverse to vernacular populism and its apparent downward pull on culture. The American domestic sphere became a site for the negotiation between modern rationalism and vernacular populism. The American home, therefore, was subject to the disciplining gaze of advertising made manifest as the modernist vernacular.

The graphic designer Paul Rand nicely summed up the mutually beneficial interests of advertising and the psychology of perception when he stated, "Perception—how

we see something—is always conditioned by what we are looking for."[60] Rand articulated the psychology of aspectual perception. Whether on a billboard, in a magazine, or on a box, advertising with the aid of psychology endeavored to predict what the consumer was searching for so as to picture it. Twentieth-century advertising achieved its goals by appealing to the fears and desires of the consumer—his or her "interest incentives"—rather than to actual needs.[61] Advertising gave form to the fears and desires of the consuming public; it offered potential ways to dispel feelings of anxiety and to enhance feelings of pleasure. Yet as Rand suggested, "what we are looking for" and a nagging sense of estrangement from others and ourselves conditioned a consuming public's capacity for anxiety and pleasure. American advertising celebrated (and continues to celebrate) an incompleteness that structures perception. In this sense, looking was a form of searching. This was at odds with Kepes's articulation of modernist advertising. He thought that advertising, if universalized, could cure this nagging sense of incompleteness or alienation. Advertising's caricatures of what concerns us are a form of what Walter Benjamin referred to as "graphic sadism" or the debasing of real fears and desires.[62] These images of the unperfected self were, in large part, instrumental to advertising's exploitationof modern disciplining arts and the popularity of vernacular motifs.

4

The history of the BRILLO® box package is, in large part, a history of the construction of an image of domestic bliss commensurable with modernist notions of efficiency. Framed by the discourses of the psychology of advertising, ego psychology, modernist design, and nationalism, the BRILLO® box has, throughout the twentieth century, pictured the social status of the American housewife. The BRILLO® pad's effective cleaning action was pictured in the mirrorlike shine of the pot, which reflected the image of the homemaker. In a later phase, the BRILLO® box represented scrubbing action. Finally, Harvey's refinement was a representation in the form of an instruction. By following the flow of the undulating line on the BRILLO® box, the housewife

mimicked (or mirrored) scrubbing action. In all cases, the BRILLO® box denoted and connoted scenes of domestic bliss, defined as a clean house and a healthy family.

The BRILLO® package design from the 1930s shows a woman gazing at her own reflection in an immaculate pot (see fig. 10). It is her mirror image that acknowledges the viewer; this image smiles and looks out from the frame of the package. "BRILLO" is set above the image. The brand name is matter-of-factly set in an outlined "grotesque"-style font in all capitals. This application of the brand name is prior to the creation of the Brillo logotype from the 1950s. A stovetop littered with pots and pans is set across the bottom of the illustration. In its combination of illustration and text, the BRILLO® box from the 1930s resembles the German *Sachplakat* (fact poster) techniques of the early twentieth century. Known for using only the necessary visual and textual elements, German designer Lucian Bernhard, the best-known producer of the *Sachplakat*, created bold messages to capture the attention of consumers.[63] His posters eschewed the ornamental excesses of the *Jugenstil* magazines and advertisements of his day. Bernhard traveled to New York City in 1922, where he stayed on and off for some twenty years and where he designed such notable visual cultural artifacts as the Cat's Paw trademark and advertisements for the manufacturer of rubber soles.[64] While not as stripped down or minimal as Bernhard's *Sachwerbung* (fact advertisement) for Cat's Paw, the 1930s BRILLO® box exhibited an equally modern style in its display of the product's "real" use.

The BRILLO® box from the 1930s exemplified a concern for household hygiene as it was reflected in the ideal image of the homemaker. This ideal image is, perhaps, familiar to visual-culture studies and art history and their reception of the French psychoanalyst Jacques Lacan's "mirror stage." In his influential article "The Mirror Stage as Formative of the Function of I" (1949), Lacan explained the role of "identification" in the formation of the "Ideal-I"—what he regarded as the image of the self that structured the development of human subjectivity.[65] In Lacanian terms, the subject who wishes to construct an ideal self looks to representations of an ideal self. Images achieve the

status of ideal only after their circulation—within mass media and visual culture—results in the establishment of norms.[66] The subject identifies with the norm/ideal, internalizing the representation and thus converting it into a cognitive entity or schema. Once converted, the subject strives to comport her body and her actions to match the ideal representation now turned eidetic. As Kaja Silverman has observed, "Indeed, to idealize an image is to posit it as a desired mirror."[67] Or we might even go so far as to say that the idealized image is a mirror of desire and that this is the logic taken up by advertising and its allocation of what Scott called "interest incentives." Advertising issues the command "Become this image." And this impracticable instruction is made manifest in the very many *mirrors* circulating in visual culture. Lacan was one of the most famous, if not infamous, interpreters of Schilder's theories of the relationship of images to the construction and ongoing management of the ego. The normative images that, as we might say, constituted a campaign for domestic order and cleanliness were part and parcel of the BRILLO® pad and the BRILLO® box package design.

Here we run into an instance of misrecognition, where the ideal image of the self is perceived as morphologically indiscernible from a cognitive picture or an eidetic image of the self. This is the logic of Lacanian "identification," where the subject takes (or mistakes) the mirror image for the self.[68] Where artworks since Duchamp's *Fountain* up to Warhol's *Brillo Box* have required, according to Danto, that perceptual skepticism guard against misrecognition, advertising required the suspension of perceptual skepticism. The consumer is intended to take the ideal image for the self as a means to become the image. This is the normative logic of images circulating within visual culture. As Scott proposed, however, these ideal images had to be familiar in order for misrecognition to take place and for the mandates of advertising to take hold.

Putting these issues of mirroring, mirror images, and misrecognitions within the context of twentieth-century domestic life and its all-too-familiar visual motifs, women were judged and judged themselves based on the appearance—the

organization and the cleanliness—of their homes. The pages of *Better Homes and Gardens, Ladies Home Journal,* and other high-circulation magazines that offered domestic advice to homemakers were replete with representation of the domestic "Ideal-I." Women saw themselves as idealized "Women" in images reproduced in mass media. While there were many such idealized images, one in particular made sense in regards to the BRILLO® box and its packaging. The design historian Adrian Forty has observed that, by the 1930s, the "aesthetic of cleanliness" dominated the "domestic landscape." That landscape was not merely manifest as the spatial organization of work but also as the organization of the visual culture of the home through magazine articles and advertisements. In other words, the "aesthetic of cleanliness" was a "visible display" of cleanliness and an exaggerated emphasis on hygiene that ruled the home.[69] All of this was literally embedded in the 1930s BRILLO® box and its use of an illustration of a housewife reflected in her pot. Although cleanliness had a direct and scientifically proven correlation to good health, what could be considered clean was equally a matter of subjective taste and fear—the beautiful and the sublime of the domestic sphere.[70] In other words, by the 1930s, one person's cleanliness was another person's pathology.[71] The anxiety felt by homemakers during the 1930s was in direct proportion to the ravages of the Depression. Forty has explained, "It seems not implausible that a regime of cleanliness and order should have been adopted by the middle class as a means of registering social upheaval and providing some psychological security against it."[72] Clean homes as well as the products that aided the homemaker were prophylactics, offering both "protection and relief."[73]

What Forty has defined as the "aesthetics of cleanliness" had its origins in the late nineteenth century and in modern scientific principles that founded the home-economics movement in the United States. Home economics, according to Nancy Tomes, taught American women to "master the invisible workings of the microbe in everyday life." And the dominance of home economics, the effect that it had on women's domestic lives, translated into a "science of a controllable environment."[74]

The home-economics movement was a means to control the microbiology-induced anxiety that women faced in kitchens that teemed with germs. Sanitary food handling at every stage of preparation was especially important to modern home economics— an idea that certainly held sway well into the later half of the twentieth century. As Mary Douglas has remarked, fears rose in response to social transformations (industrial advances, economic booms, depressions, and civil and world wars, for example) and so, too, did the demand for a clean and orderly person and environment.[75] In fact, immigrant women who were born and raised in the first quarter of the twentieth century took housecleaning and sanitary food preparation as a "sacred duty."[76] (No doubt this category included Warhol's mother, Julia Warhola, and was incorporated into his *Brillo Box* archive.) This sense of duty was certainly passed on to daughters of the Depression-era generation of women attentive to the hygienic status of the home.

These aesthetic and hygienic concerns structured BRILLO® ads from the 1950s and 1960s. BRILLO® pad ads in the 1950s showed a happy family reflected in a shiny pot. Here the mirrorlike image of the mother, son, and daughter, an image reminiscent of the 1930s ad mentioned above, denoted the cohesive family unit and promoted a healthy togetherness. This image was familiar enough, as it was a mainstay of 1950s television programs and films. In the ad, the children are shown to have benefited from their mother's attention—she enfolds them—which was made possible through BRILLO®'s "speedier shine—more free time." In another advertisement from 1959, a pot reflects a pristine image of a father and mother playing with their young child (fig. 11). Here cleanliness equals domestic bliss. In keeping with the imagery of hygiene and the "aesthetics of cleanliness," ads for BRILLO® soap pads from 1960–1961 proclaimed, "The shine is the sign it's really clean!" (fig. 12). In addition to the ads' recurrent headline, the fictional spokesperson for BRILLO®, Prudence Potts, the Pan Inspector, added, "Of course you want a shiny pan to cook your family's food in." In another ad, Potts stated, "Not a speck, not a spot on a Brillo bright pot." And in another,

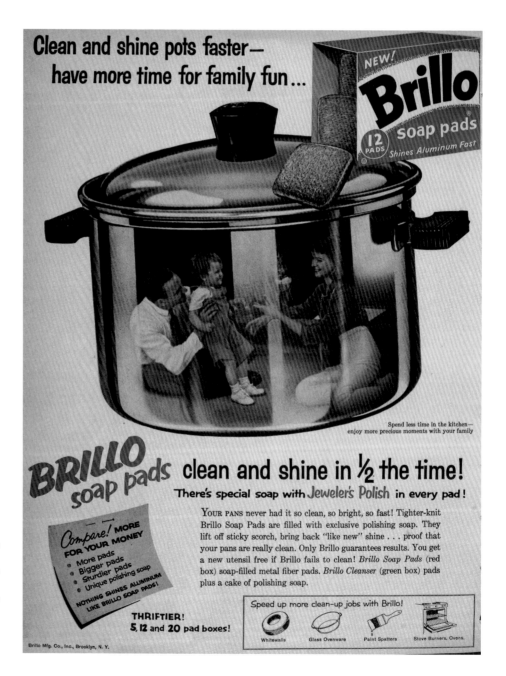

"Nothing makes me gladder than a pan that's Brillo bright." Of the three, Potts's first statement directly addressed the homemaker's self-interest and sense of well-being. The fictional character's lightly admonishing tone appealed to the homemaker's desire to keep her family healthy and to insure against bacterial contamination of food cooked in a dirty pan. "The shine is the sign it's really clean!" tag line implied that the pot's gleaming surface literally signals or signifies cleanliness to the eye, appealing to the homemaker's desire to maintain a healthy home.

Harvey's redesign of the BRILLO® box—its hard-edged and apperceptual impact—inaugurated a new advertising campaign for BRILLO® soap pads (fig. 13). The juxtaposition of the BRILLO® box with a pan in the midst of scrubbing created a relation between the product and its application. Yet closer scrutiny reveals that the grease-cutting "scrub bubbles" and coarse texture of the pad produced a spiral pattern that was perceived as an extension of the white undulating (or waving) form on the box. The visual connection between the diagrammatic flow of the box's curving graphic and the actual scrubbing action performed on the pan represented the long-standing goal of "sanitary awareness."[77] While all three boxes and accompanying ads pictured the relationship between the aesthetics of cleanliness and domestic bliss, it was the final ad and Harvey's design that reinforced physical action in the home as a disciplinary mode of social reproduction. Harvey's BRILLO® box visualized a social climate where women became extensions of modernist rationalism compatible with Nixon's example of the American kitchen as the site of technological advances.

Histories of science and technology have tracked the ongoing organization and rationalization of the domestic sphere.[78] By rationalization, I mean an impulse to organize aspects of experience according to logical and observable principles. The impetus of the rationalization of the domestic sphere was toward the attainment of what Sarah Leavitt has defined as a "modernist fantasy" of control equaling freedom.[79] The home as a site of personal perfection—what I refer to elsewhere as "being at home

Fig. 13: Brillo advertisement, 1961. Use of the BRILLO® box, the BRILLO® trade dress and the BRILLO® print ads is with the express written permission of Church & Dwight Co., Inc., Princeton, New Jersey. BRILLO is a registered trademark of Church & Dwight Co., Inc.

in the world"—was also a site of conflict between the pursuit of self-improvement and the regiment of social conformity.[80] Such ambivalence resulted in the attainment of new levels of household efficiency and the establishment of new modes of self-surveillance, both of which were represented in the history of BRILLO® box design and advertising. Considered in this way, rationalization of the domestic sphere was also the observation of the (gendered) self within a scientifically managed environment. For example, Christine Frederick's methods of automating the home, modeled after the radical productivity of industrial capitalism, transformed the homemaker into one of many ready-made elements inserted into a system of production. In the spirit of Frederick Taylor and the Gilbreths, Frederick streamlined the home, doing away with any number of idiosyncratic tendencies and self-serving specialties, to the extent that all home functions became mechanized. Certainly, an efficient household could result in less labor for the homemaker, which, in turn, could equal more leisure time. But, it was also the case that an efficient household was a clean household, which was subject to public scrutiny. In fact, the rhetoric of efficiency that Frederick first introduced into the household was equivalent to the rhetoric of hygiene and health maintenance. By the 1950s and early 1960s, scrubbing, as represented in the BRILLO® ads, was a form of social indoctrination such that self-presentation became associated with self-preservation. The maintenance of social norms—such as nation and family— became an imperative that faced and gave character to the ongoing transformation of the domestic sphere in the United States.

5

Drawing on the lessons of the psychology of advertising and the domestic-engineering movement, the BRILLO® box became a national symbol of modernist rationality in the home. Here words—ordinary discourses—were transformed into things: real boxes and real actions that responded to the normative procedures of the home. All these relationships among statements, debates, descriptions, propositions,

evaluations, prescriptions, and criticisms constructed the object: BRILLO® box in culture. In addition to its reinforcement of the general objectives of marketing BRILLO® pads, the box reproduced the technological and social patterns of housework, celebrated in Nixon and Khrushchev's Kitchen Debate. Khrushchev was spot-on when he defined the model kitchen as an example of the "capitalist attitude towards women." Such an attitude, shaped by the compatible agendas of advertising and nationalism, constructed the cold-war American home as a site of a modernist vernacular. Indeed, while the universalist principles of modernist design were at odds with the particulars of the American advertising vernacular, the BRILLO® box, framed by the domestic sphere, confronted the specificities of self and nation with the generalities and unifying trends of an increasingly rationalized society.

The BRILLO® box, of course, was not the only object constructed in discourse. As discussed above, the consumer embodied this reconciliation in her scrubbing action. She was a component part of the *Gesamtkunstwerk* that resulted from the alliance forged between mass culture and society in the postwar era. An advertisement from 1959 showed three gendered uses of the BRILLO® pad: "shines aluminum ware, brightens shop tools, sparkles linoleum." Under each description is an illustration, with a housewife holding a pot, her husband in his workshop, and the same housewife in her kitchen. In each case, the pad's effective scrubbing action is assigned to specific gender roles and spaces within the domestic environment—women in the kitchen and men in the workshop.

The consumer holding tight to her BRILLO® pad and her dream of an ideal home was on the receiving end of Gyorgy Kepes's "positive popular art" and all the debates that contributed to its influence on design practice. Advertising and marketing illuminated the reflective surfaces of the kitchen that rendered the housewife visible to herself, to her family, and to her neighbors. Her ego ideal imaged in these reflective surfaces was enacted at the end of a BRILLO® pad. The work of a "positive popular art" was, nevertheless, not foolproof. A negative tension existed with the graphic

design and the communicative action of the object itself. The abstract image of the American flag that Harvey integrated into the BRILLO® box design signified, however unreal, a tradition of independence or individualism in America. Individualism in contrast to what Wilfred McClay has defined as "a deification of organizational life" in American life made for a contradictory marketing message—if indeed we take the BRILLO® box package as a form of mass media.[81] The conformity-driven milieu of American advertising—its visual clichés and its reinforcement of social norms— clashed with the mythos of the independent American. The same paradox, some would say hypocrisy, structured Nixon's comments during the Kitchen Debate. The vice president's equation of technology and kitchen equal "freedom" replicated the duplicity of cold-war rhetoric: The kitchen as the focus of organizational and managerial techniques became a symbol of personal independence and national sovereignty. Of course, Nixon's remarks depended on an already existing set of assumptions about technological and scientific progress and freedom.[82] While Harvey's BRILLO® box design neatly juxtaposed flag waving and pot scrubbing, the two ritual activities existed in an uneasy relationship with American culture, its promise of total freedom and advanced technology, and its promise of total control.

Art

1

Broadly speaking, claims that have been made about the relationship between popular imagery and Pop artworks like Andy Warhol's *Brillo Boxes* have ranged across three general descriptions: First, that the relationship between Pop Art and popular culture passively affirmed the influences of postwar market capitalism in the United States. Second, that the use of popular imagery in Pop artworks undermined conventional standards of taste. And third, that the use of popular imagery in Pop artworks was indicative of an aesthetic rebellion comparable to political radicalism in the 1960s.[1] In all three cases, it can be construed that Pop Art archived aspects of modern life—what Henri Lefebvre once called "everyday life in the modern world." Lefebvre underscored a sense that everyday experiences are structured by negotiations with the creation

of consumer desire through marketing and advertising.[2] No doubt, Warhol made every-day experiences a structural component of his ar works, as they were "constructed" by the pressures of marketing and advertising and as they were informed by psychology and the behavioral sciences. On this point, Warhol commented:

> *The pop artists did images that anybody walking down Broadway could recognize in a split second—comics, picnic tables, men's trousers, celebrities, shower curtains, refrigerators, Coke bottles—all the great modern things that the Abstract Expressionists tried so hard not to notice at all.*[3]

What Abstract Expressionists failed to notice was the everyday stuff of contemporary culture; Warhol's project was to notice what went unnoticed. In other words, his project was to create archives of the neglected or unobserved patterns of modern life. He saw this as a form of working through the debris of culture: "I always like to work on leftovers, doing the leftover things. . . . It was like recycling work."[4]

Warhol claimed that the documentary filmmaker Emile de Antonio laid the groundwork for his practice. De Antonio taught Warhol to see "commercial art as real art and real art as commercial art, and he made the whole New York art world see it that way, too."[5] There is no question that de Antonio's influence impacted Warhol's artistic practice, a practice that I will define as anthropological in its motivations. Warhol's penetrating observations of contemporary culture—his recyclings—were, what the artist Joseph Kosuth considered a "model of the anthropologist *engaged.*"[6] Warhol's decision not to ignore "all the great modern things" was in keeping with Kosuth's sense of the benefits of an art/anthropology immersed in contemporary culture. It was the case that Warhol was predisposed to de Antonio's teachings. While de Antonio made Warhol aware of the mutually informing disciplines of commercial art and fine art (to see one as the other), it was his

education at Carnegie Technical Institute in Pittsburgh (Carnegie Tech) and the influence of Robert Lepper that provided the artist with the tools to study culture—namely, the work of the cultural anthropologist Ruth Benedict.

In the previous chapter I remarked that there has been a failure to attend to the significance of James Harvey's design of the BRILLO® box, and that this failure has resulted in there being no account of Warhol's *Brillo Box* that satisfies the question of the artist's interest in Harvey's box as a cultural artifact. I want to take this question up again, but from the other side. Where I explored how Harvey's BRILLO® box was situated within discourses on modernist design that resulted from the rationalizing tendencies of the household-engineering movement and the vernacular of American advertising and marketing, here I will focus on Warhol's *Brillo Box* as taking issue with the disciplining tendencies of the cultural artifact. In this sense, Warhol lives up to Kosuth's idea of the artist as a "model of the anthropologist *engaged*." Such a commitment to anthropological procedures produced artworks like the *Brillo Box* that archived or stored the patterns of belief and habits of life that constituted contemporary American culture.[7] On the one hand, Harvey the designer worked to inscribe his BRILLO® box with these patterns and habits. The discourses that framed his box were informing and productive. The result was the consumer's embodied articulations of household patterns and habits as they were socially reproduced in popular culture. On the other hand, Warhol worked to expose or to bring to consciousness through his *Brillo Box* the same patterns and habits that structured the everyday lives of consumers. Thought of in this way, Warhol's *Brillo Box* archive disrupts the rationalizing discourse that constitutes Harvey's BRILLO® box archive by exposing its visual logic. Importantly, Warhol's anthropological/archival work showed that the artworld was not immune to the discourses that worked to normalize culture. Perhaps this is what he meant by seeing "commercial art as real art and real art as commercial art" and why

he did not neglect "all the great modern things that the Abstract Expressionists tried so hard not to notice at all."

It is possible that an account of Warhol as the artist/anthropologist could be taken as an affirmation of what Benjamin Buchloh once called Warhol's "participatory aesthetics," which resulted in the inscription of the viewer "literally, almost physically, into the plane of visual representation in what one could call a 'bodily synecdoche' —a heroic tradition of twentieth-century avant-garde practice."[8] The idea of participation as a means of standing in someone else's shoes is, as Buchloh has remarked, "one of the strategies, if not the key strategy, of advertisement design itself, soliciting viewer's active participation as *consumption*."[9] Buchloh discusses Warhol's dance-diagram paintings, but his analysis easily applies to the *Brillo Box*. For Buchloh, advertising and marketing establish a false universality that eclipses all forms of authentic cultural expression. Thus, dancing and scrubbing, like all other forms of culture, are grist for the mill of consumption in postwar American culture.

Thought anew as an instance of cultural criticism, Warhol's "participatory aesthetics" was an anthropology of the normal; it was a critical representation of social and cultural norms reproduced in a variety of visual forms that contributed to the disciplining of everyday culture. These norms can be seen in Warhol's works from the early 1960s, namely, the diagram paintings—*Where Is Your Rupture* (1961), *Fox Trot: "The Double Twinkle—Man"* (1962), *Male Genital Diagram* (1962), *Do-It-Yourself (Flowers)* (1962), and *Brillo Box* (1964). In this chapter I will focus on two works, *Fox Trot: "The Double Twinkle—Man"* and *Brillo Box*. *Fox Trot*'s fragmented image—its dislocation of the left foot—and *Brillo Box*'s superclean appearance and its organized-to-look-disorganized installation managed to upend the dominant markers of the culture industry and its investment in and construction of social norms. From this perspective, a viewer experienced *Fox Trot* as a kind of "social" dance because the program determined his or her dance as a means of cultural assimilation. And in the case of *Brillo Box*, a viewer was situated within the space of consumption as a form of cultural

assimilation. And yet, unlike his peers in marketing and design who were committed to exploiting the ability of the diagram to make rational and logical forms of life visible, Warhol in his diagram paintings and boxes was exploring what defies "imagability" (to use a term coined by Kevin Lynch in the early 1960s) or, to be more precise, what was *not made visible yet* in the archive but that was coextensive with the social field. His diagrams and boxes disrupted norms by excluding or rearranging crucial bits of information such that the actions that constitute culture are not reduced to the constructive force of discourse.

If psychologists, visual artists, and designers embraced the concepts of diagram and schema as contributing to social order and cultural stability in a period of postwar conservatism in the United States (as I discussed in Archive 2), then Warhol's *Fox Trot* and its missing foot (number 7) and the near-blinding whiteness and disarray of the *Brillo Boxes* undermined the organizational nature of popular dance and housekeeping and their mutual collusion with normative ideologies in the early 1960s. What was not yet visible in Warhol's *Fox Trot* and *Brillo Box* was a potential for spontaneous action as a form of excess produced by the culture industry. The missing foot implied in Warhol's *Fox Trot*, then, animates the dialectical tensions in a "participatory aesthetics" and makes it over into an anthropology of the normal and a demystification of the mysteries of the everyday—or as Warhol would say, all the "great modern things." Warhol's diagram paintings and objects, while complicit with the organizational habits of the immediate postwar era, resisted pressures to rationalize experience and, as a by-product of rationalization, contribute to the normalization of culture in the postwar era.[10] As an anthropological archive of patterns of culture, Warhol's *Brillo Box* is always incomplete in that we cannot see in it all possible actions reduced to discourse. Thus, Warhol's *Brillo Box* archive is an archive interrupted.

2

The systematic and positivist approaches to psychology, psychoanalysis, and design that I discussed in Archive 2 coincided with the education of artists and designers in the postwar era. In Warhol's case, it was his tenure at Carnegie Tech in the late 1940s and his exposure to Robert Lepper that introduced him to the idea of the potential of the visual arts to establish "'stability' or 'equilibrium' within the 'social organism.'"[11] Lepper's influence on Warhol was such that the artist maintained contact with his teacher, sending him updates on his rise in the international artworld.[12] However cautious or conservative his early art and design training may seem, Warhol remained under its influence; he worked to advance his art in new and critical directions that were informed by his early education. It was also the case that Warhol's professional career as an artist ran concurrent with critiques of theories of cultural conformity and social integration in psychology, the visual arts, and aesthetics. Although he was not aware of efforts to disabuse psychology of its attempts to establish personal and social harmony through identifying and promoting functional normalcy, Warhol's painted diagrams underscored the dimensions of discord between viewing and acting, between diagram and schema, and between perception and the body.[13]

Warhol's Rorschach paintings series (1984), however, suggests that the artist was invested in an interrogation of the relationships between perception, institutional discourses, and cultural norms. Indeed, the diagnostic work of the Rorschach test of personality traits is based on the principle of "seeing as" or aspectual perception.[14] Presented with the standard symmetrical "blot," a subject of the test might see it as a butterfly or as a pelvic bone. The clinician provides what Wittgenstein would refer to as the "caption" that determines the proper meaning of the blot.[15] In either case, an accumulation of such instances of "seeing-as" result in a personality type or category. Therefore, some interpretations were "normal," and others were not. Warhol's *Rorschach Painting* is an instance of noticing a specific quality or characteristic of something—what Wittgenstein calls "seeing-in"—or an archive of the discourses in psy-

chology that furnish the methods for interpreting the meaning of butterfly or pelvic bone (fig. 14).[16] Very much like Michel Foucault's example of the discourse of psychopathology and its "formation" of the "madman," a viewer sees in the painting the institutional logic of psychology and the discourses that construct its objects.[17] When exhibited at the Gagosian Gallery in 1996, Warhol's large-scale paintings (as large as 164 by 115 inches and as small as 20 by 16 inches) could not be mistaken for mere Rorschach inkblots, and thus the institutional test of seeing-as was over taken by the archival task of seeing-in.[18]

This was also the case with the *Brillo Box*es. They, too, invite aspectual perceptions. Here, Warhol's production and installation of the boxes heightened his viewers' appreciation of the disciplining tendencies of household products, reframed by the Stable Gallery installation and archived in the *Brillo Box*es. They really could never be mistaken for the BRILLO® boxes found in the backrooms of supermarkets, as Danto claims. Warhol understood that Harvey's BRILLO® boxes exploited the impact of the diagram on the schema of self-identification—in this case, the identification of the self as a homemaker within the context of household engineering. No doubt, Warhol's close relationship with his mother made him acutely aware of the organizing principles of domestic science as immigrant women in the United States adopted them. As a young child, Andy often sat with his mother in the kitchen while she told him stories of the old country and cooked and cleaned.[19] Later, in 1952, when Julia had moved to New York and in with her son, Warhol counted on her to care for his home, first on East Seventy-Fifth Street, then at 242 Lexington Avenue, and then at 1342 Lexington Avenue, until she died on November 22, 1972. Notwithstanding his acknowledgment of past influence, Warhol rethought (or recycled) a previous generation's faith in a totalizing view of the structuring potential of visual arts and design and transformed such a view into anthropology. In other words, Warhol understood that culture was built up from these very diagrams for dancing and cleaning. These diagrams established accepted patterns of culture that developed from dating, marriage, and housekeeping.

In the mid-1940s in the United States, most art schools emphasized art and design studio courses and neglected general education. The Carnegie Tech program was unique in its emphasis on an integration of liberal arts and sciences with art and design-studio courses. In addition, entry into the school's programs required a rigorous vetting process. Prospective students to the College of Fine Arts had to endure a grueling series of placement tests in addition to submitting qualifying grades from high school. The technical-skills tests determined the level at which the student would begin, if indeed he or she would begin studies at Carnegie Tech at all. The entry exams that Warhol took for the Department of Painting and Design lasted four days. The challenge created a sense of accomplishment in the new student and promoted an atmosphere for serious study. In addition to the standard fine-arts and design courses, students in the department were required to take Thought and Expression, one of the general-education courses that also included History of the Arts and Civilization, Individual Psychology, and Social Orientation. Each of these courses was in keeping with positivist tendencies. After his first year, Warhol enrolled in summer school, retaking Drawing I with Russell Hyde. The course plan required that students do fieldwork, closely observing their environs and visually reporting on persons and activities. Embarking on his second year at Carnegie Tech, Warhol took still-life painting with Samuel Rosenberg, who emphasized techniques for aiding memory and increasing the ability of the student to render the natural world with expressive accuracy. Mood and feeling in art were key attributes of painting for Rosenberg. While Warhol did well in Rosenberg's course (Rosenberg was one of his strongest supporters), he especially excelled in a course on pictorial and structural design. Taught by William Charles Libby, the course was intended to train commercial illustrators. While Warhol had a difficult time with the courses required by the College of Fine Arts, he had better luck with academic themes when they were integrated into studio projects. During his third year, Warhol declared Pictorial Design (or commercial

OPPOSITE: Fig. 14: Andy Warhol, Rorschach Painting, 1984. Archives Study Center, Andy Warhol Museum. © 2007 Andy Warhol Foundation for the Visual Arts / ARS, New York. © Andy Warhol Foundation/CORBIS.

illustration) as his major. The decision resulted in his taking courses with Robert Lepper, the most conceptually minded instructor in the Department of Painting and Design. Lepper's courses were devoted to near-yearlong projects that were sociological or anthropological in nature. The "Oakland Project" was one of his research-intensive projects.[20]

The Oakland Project required students to study a section of Pittsburgh adjacent to the campus of Carnegie Tech.[21] Lepper instructed those in his class to find a building in the working-class Oakland district and draw that building; they were to pay close attention to all of its exterior detail. Lepper advised his students not merely to draw their subjects but also to further create categories such as "people, shelters, goods and services, topography, public service, ceremonial observances, and government activities."[22] Then, having produced a database of visual types from the neighborhood, students were to imagine the interior of the building based on their knowledge of who the inhabitants might be. This speculative portion of the program was informed by the extensive observations made by the students on the streets of the district. While many, if not most, of the Carnegie Tech students were not from the area, thus having no access to the interiors of the buildings, Warhol was from the neighborhood. The results of his observations were not speculative because he drew his own living room. Warhol had the advantage of being a "participant-observer" in his research.[23]

To aid his students with their research and to help them become "pictorial anthropologists," Lepper assigned Ruth Benedict's *Patterns of Culture,* a bestseller that in 1934 had introduced the lay public to the subject of anthropology.[24] Her stress on cultural diversity—an idea that she took from her mentor, Franz Boas—struck a chord with the American public. And yet, *Patterns of Culture* was at odds with the increasing popularity of eugenics, biometrics, and with the search for the "universal Caucasian" in the United States, best exemplified by the *Norma and Normman* (or *Norm-a* and *Norm-man*) sculptures produced by Dr. Robert Latou in 1942. Both sculptures were based on the biometrics of fifteen thousand "native white Americans."[25]

It is unclear if Lepper was sympathetic to such an application. For him, pictures were the result of observations; in other words, they were visual records of empirical data and thus could be compared to the original visual event. Following procedures first introduced in the nineteenth century and the natural sciences, pictorial modes of recording phenomena were revolutionized by the use of photography (then thought to be an objective form of observation). Yet all forms of pictorial representation were considered useful in a quest for the accumulation of the facts of the world. As David Green has remarked, "pictorial representation became the most adequate metaphor for an epistemology based on empiricist methodologies."[26] Perhaps Lepper assigned Benedict's book because, while empirically sound, it still maintained a humanistic attitude toward its representation of culture. While Lepper was invested in the project of positivist empiricism, his courses emphasized observation rather than mechanical recording. They were not in search of universals. Indeed, Benedict tolerated difference in the unifying and habit-making patterns of culture, an attitude not generally shared by others in her field. In fact, this was precisely the lesson that Warhol learned from the project.

According to Benedict, patterns that develop from the "miscellaneous behavior directed toward getting a living, mating, warring, and worshipping" construct culture.[27] The individual personality, Benedict argues, is mutable. The dominant culture dictates the behavior, thoughts, and emotions of individuals and groups. The "habit-patterns" made manifest in "living culture" are traces of traditional customs; the study of the "simpler people" of a culture provide the cultural anthropologist insight into the formative customs of a culture.[28] This correlation can be made because "individuality personality is in a sense isomorphic with culture."[29] Benedict's *Patterns of Culture* was contemporaneous with ego psychology in the United States. Both her anthropology and ego psychology investigated the links between culture and conformity, at a time when most cultural anthropology in the United States subscribed to the mainstream in psychology. Benedict, like others who had studied with or were influenced by

Boas, was opposed to the strains of uncritical positivism in psychology. Benedict differed from the positivist approaches taken by her colleagues in psychoanalysis and psychology when she proposed that individuals whose conduct was far removed from the social-cultural mainstream would always be at odds with cultural norms.[30] Yet, she continued, such a conflict resulted in a socially sanctioned prejudice that adversely affected those on the margins of society. Benedict believed that her book would make her audience aware of the social inequities that arose from taking social and cultural traits as natural, and thereby promote "tolerance and appreciation" for those outside of the mainstream.[31] With this thought, Benedict anticipated Herbert Marcuse's devastating observation that "in a repressive society, individual happiness and productive development are in contradiction to society."[32] As such, both happiness and development are outside discourses that seek to construct objects in keeping with the status quo.

Warhol responded to Lepper's Oakland Project and Benedict's *Patterns of Culture* by producing *Living Room* (1948), a painting that was anthropological in Benedict's sense of a record of a form of life and in Lepper's sense of the "pictorial anthropologist" who recorded the "patterns of culture" represented by the daily activities of the working-class inhabitants of the Oakland neighborhood. The moment pictured in Warhol's painting was one where the young artist realized the class position often adopted as subject matter by realist painters as a cultural heritage. Having occupied the working-class living room in his painting, Warhol embodied (at the level of schema) what he represented (as a diagram). By "embodied," I mean that Warhol's social status as working class was not simply a category that was applied to the Oakland district but was a constitutive aspect of his lived experience up to and during his years at Carnegie Tech. In other words, Warhol did not observe the pattern of culture from an objective viewpoint but was from a position that was knit into that pattern. In Warhol's case, class was not merely a category of social standing. This diagram of social experience—the manner in which the painting presented the interior space as

constraining—differed from classical Marxist theories of class consciousness, in which it was understood that strict social distinctions form classes through the distribution of owned property and accumulated wealth.[33] Warhol's living room was literally a space to live in, a space that he lived in. The diagrammatic character of Warhol's painting is what Meyer Schapiro meant when he observed that the conditions of class can be "discovered in the very fabric of painting."[34] Every item in that room and the arrangement of them was the result of long-standing cultural patterns established in the peasant villages of the Warhola family's Ruthenian heritage and transferred to their working-class Pittsburgh home.[35] The living room in the United States—and not in Czechoslovakia—created a formative context for Warhol's ongoing experiences of the world.

3

From the "pictorial anthropology" of *Living Room* to his drawings of the partially exposed bodies of local women making daily purchases in the working-class neighborhoods of Pittsburgh in the late 1940s to his inkblot commercial illustrations in the 1950s to a pair of breakthrough paintings that Warhol produced in the early 1960s and titled *Storm Door,* we can trace a progression from the representation of patterns of culture to an archive of patterns of culture.

Warhol's shift from a conventional to an archival approach to representation is best exemplified by *Storm Door* (1961) (fig. 15) and *Storm Door* (1962) (fig. 16). The version from 1961 exhibits drips and sketchy areas of thinned paint. The 1962 version, a painting virtually identical to the previous painting, is painted in a hardedge style similar to commercial sign painting. As the editors of Warhol's catalogue raisonné explain, Warhol accomplished the precision of this version of the painting by using masking tape to produce hard edges.[36] The differences go beyond his handling of paint. *Storm Door* (1962) pushes the image of the window forward, and, even though the canvas appears to be less worked over than in *Storm Door* (1961), it is more

THE DOUBLE TWINKLE -- *Man*

START

Review

The foot pattern for this figure is:

1. Forward *(Slow)* 2. Forward *(Slow)* 3. Forward *(Slow)* 4. Side *(Quick)*
5. Side *(Quick)* 6. Cross *(Slow)* 7. Side *(Quick)* 8. Side *(Quick)*
9. Cross *(Slow)* 10. Side *(Quick)* 11. Side *(Quick)* 12. Back *(Slow)*

65

OPPOSITE: Fig. 17: Andy Warhol, Fox Trot: "The Double Twinkle—Man," 1962. Archives Study Center, Andy Warhol Museum. © 2007 Andy Warhol Foundation for the Visual Arts / ARS, New York.

ABOVE: Fig. 18: Source for Warhol's Fox Trot, page from Fox Trot Made Easy, 1956. University of Texas, Austin.

aggressive in its upfrontness.[37] In this sense, the door is a diagram of inaccessibility. The 1962 version of *Storm Door* is a study in the "practice of negation" in that the previous generation's skills and frames of reference for paintings are "avoided or travestied."[38] Its flatness is as close to sign painting as the Hardedged Abstractions of Stella and Noland are to house painting; both the Pop artist and the abstractionists court the flat fact of painting. Where Warhol's *Storm Door* (1962) differs from more conventional abstraction is that the reproduction of a diagrammatic rendering of the door proffers a semantic density—its simultaneous references to Mark Rothko's compositional structure and to middle-class utility—that is nowhere found in Stella or Noland. In other words, not only can we see the basic character of the hardware advertisement in the painting, but we can also see the inaccessible abstractions of Rothko, Stella, and Noland in *Storm Door* (1962).

These same issues become all the more acute when considering the "practice of negation" in Warhol's *Fox Trot* (fig. 17) in the context of ego psychology in the United States and its study of the relationship of the image of the human body to human subjectivity and the establishment of normative behavior and social-cultural assimilation. The underlying assumption was that certain images, pictures, or visual representations could provide models for normal conduct. In the visual arts, theories of physioperceptual models were adopted to art and design education. In Warhol's particular case, his adaptation of these earlier techniques resulted in an appeal to a viewer's embodied subjectivity. His *Fox Trot* forcefully demonstrates the significance of the diagram as a graphic representation that thematizes the dialectics of subjective experiences within a social-cultural context.

Warhol's source materials for *Fox Trot* were instructional books, like those published by the Dance Guild, popular in the United States and intended to teach its audience how to dance (fig. 18). The vaudeville performer Harry Fox originated the

dance on the Ziegfeld stage in 1914. Vernon and Irene Castle later refined it. The fox trot introduced basic steps for most ballroom dances. As such, it has been a staple of the ballroom scene, though it was not very popular in the early 1960s.[39] As a ballroom dance, it was the dance of an older generation, even though as late as the 1950s, rock-and-roll music was marketed as music for the fox trot. The fox trot's popularity coincided with the shared positivism between ego psychology and positivist theories of representation in the visual arts. The waning of the popularity of the dance, likewise, coincided with the rise of skepticism toward making psychology more scientific and more pertinent to the pressures of assimilation into American society.

Originally exhibited at the Sidney Janis Gallery's New Realists show, Warhol installed *Fox Trot* on the floor, just below Robert Indiana's *The Black Diamond American Dream #2* (1962). He set the canvas horizontally into a manufactured framelike base raised several inches from the floor. The background is white. In the foreground, the diagram of dancing feet creates a black cruciformlike diagram. The left-foot image is an outline, and each right-foot image is solid. Each foot image exhibits a letter "R" or "L" that designates "right foot" or "left foot" to the beholder (dancer), and each foot image has a corresponding number—1 through 12—that indicates the order in which each foot moves. Arrowed lines illustrate the direction of the movement of each foot. The upper left-foot image ("R8") and the upper right-foot image ("R4, 10") are slightly cropped at the right and left edges of the canvas. Warhol did not include a step with the number "7" in his painting. The arrow and line that are drawn from the left side of the canvas imply the presence of the left foot, however. Looking down at the canvas, a viewer notes that each foot image is life-size.

At the basic level of diagram, Warhol created a dialectical dance by cropping out step number "7." The cropping, though suggestive of the foot's presence, does not indicate its exact or programmatic position in relation to the other steps in the painting. While steps "1" through "6" and "8" through "12" are in place and therefore have to be followed, step "7" remains uninscribed and therefore frees the

foot and, by extension or in the case of synecdoche, the entire body at this point of the program. It is at this point that the viewer of *Fox Trot* is, aesthetically speaking, out of step with the mainstream of the culture industry and the programmatic nature of the dance. Any further step taken is in excess of the culture industry's determining diagrammatics. This step even goes so far as to defy Warhol's archival project. Such a position on the normative program of dance and other social activities was reminiscent of Warhol's favorite passage from Benedict's book: "Middletown is a typical example of our usual urban fear of seeming in however slight an act different from our neighbors. Eccentricity is more feared than parasitism."[40] Perhaps the most that can be said here is that Warhol did not literally picture a crucial step in *Fox Trot*, thus the artwork's social and cultural meanings figuratively pivot on where the missing foot could potentially land. The step is spontaneous only in the sense that it is not made visible as an instruction. This does not mean, however, that the step is any less programmatic, since the unknown step forces the dancer/viewer to draw on past experiences of dancing/viewing to circumscribe his or her new experience of dancing/viewing now. The missing foot also implies the *missteps*, from a perspective taken by the dominant culture and pathologized by ego psychology, made by those individuals who do not follow prescribed social norms.[41]

There also exists the notion of Warhol's dance diagram as a commentary on an older, "square" generation, as well as discussions on the relationship between Warhol's dance diagrams and Pollock's so-called drip paintings. The placement of *Fox Trot* on the floor of the Sidney Janis Gallery has indicated to Rosalind Krauss that Warhol and Pollock established their critical nexus at the "structural level of *form*" on the floor.[42] For Krauss, the "*form*" on the floor mediates between Pollock's dance and Warhol's dance. Warhol's *Fox Trot* and Pollock's drip paintings shared a horizontal orientation that celebrates the "wild heedlessness" of the floor; and both artists had the image of the literal or implied footprint in common.[43] Between 1950 and the artist's death, Hans Namuth made two films and approximately five hundred photographs of Pollock

at work. Importantly, according to Francis V. O'Conner, the films and photographs "make explicit Pollock's famous and seriously misunderstood painting technique."[44] Better still was the fact that Pollock was literally pictured dancing around his floor-based paintings, what O'Conner has described as "gestures of bending, kneeling, stretching, and straddling."[45] The kinesthetics and calisthenics of Namuth's photographs, especially, pictured Pollock stepping around his canvases, stepping onto his canvases, and stepping back to evaluate his steps. Namuth's photographs gave the progression of these steps a certain rhythm; they had the look of a spontaneous dance. Perhaps Warhol was quick to pick up on the lack of *real* spontaneity in Pollock's dance for Namuth. His dance diagrams also underscore the "twinkle toe"–like quality of Pollock's dance, perhaps referencing its potential effeminate qualities and ratcheting up the irony one more notch.[46] At the very least, Warhol understood that Namuth's photographs, in addition to the numerous articles that focused on Pollock at work or in the studio and so contributed to Pollock's mythos, constituted a discourse that constructed both the art and the artist. These images then became a pattern that subsequent artists could follow, thereby normalizing Pollock's radical actions. Painting like Pollock was thus comparable to dancing the fox trot: Both were out of date and should be relegated to the archive.

Viewers see commercial art as fine art and fine art as commercial art in both versions of *Storm Door* and in *Fox Trot*. The play (or Gestalt switch) between aspectual perceptions is achieved through the use of images drawn from everyday examples of common culture—storm doors (or windows) and fox trots. The shifts in seeing-as organize the perceptions had by viewers such that they can make the very comparisons between artworks and commercial objects that Warhol established as a practice. At first, viewers see the painting as an illustration of a storm door or a diagram for a dance; then they see both as artworks. The crucial archival move, however, was for Warhol to organize the perceptions had by viewers so that they could see the object constructing discourses of Abstract Expressionism and Hardedge Abstraction in *Storm*

Door (1962) and *Fox Trot*. In the case of *Fox Trot* and its missing foot, Warhol disrupts the prescribed projections that motivate instances of seeing-as and seeing-in. The missing foot in *Fox Trot* is the remainder outside of discourse. It is unknown. Perhaps this was the unknown factor in Lepper's "pictorial anthropology"? Observation can lead only so far. There were things and actions that were unobservable and therefore were not representable.

4

As discussed in Archive 2, Harvey's BRILLO® box was normative in its diagrammatic prescription for the proper movements of the housewife or homemaker in the kitchen. Like the diagrams for popular dances and their patterns of acceptable social interaction and assimilation, the BRILLO® box endorsed the reproduction of normative behavior in the home. Like the participatory action that the fox-trot dance presumed of dancers, Harvey's BRILLO® box indexed the movement of the scrubbing hand of the housewife as it extended her body to meet the needs of the post–World War II home. The prosthetic nature of the scrubbing pad aided women in their quest to achieve (however impossible) the "aesthetics of cleanliness." Considered in this way, Harvey's BRILLO® box was an image of efficiency and cleanliness that was informed by discourses on household hygiene dating back to the nineteenth century. Like Pollock's paintings and Namuth's photographs of Pollock painting, Harvey's box took the form of an instructional diagram rather than merely being an indexical mark left in the wake of the housewife's scrubbing action. In this sense, the BRILLO® box anticipated the movements in the home, just as Lillian and Frank Gilbreth's time-motion studies had anticipated the future movements of bricklayers and factory workers. Herbert Matter's chronophotographic image of a man dressing best expressed this study of movement. Warhol would have seen this image as it was reproduced in Laszlo Moholy-Nagy's *Vision in Motion*, a book that, according to Robert Lepper, Warhol consulted on occasion.[47] Furthermore, much as if following diagrams of popular dances, housewives across the

United States performed the movements diagrammed by the BRILLO® box's undulating line. And much like the normative practices of heterosexuality embedded in the social dance, the box's diagrammatic instruction presumed that heterodomestic bliss was on the horizon for the women whose hands mimicked its unattainable future-directing line. As advertisements for BRILLO® pads suggested, American housewives could see their bright futures in the clean surfaces of their scrubbed pans.

Warhol saw these normative tendencies in Harvey's BRILLO® box, just as he saw the social and cultural implications in the preprogrammed movements of the dance diagrams for both popular dance and making art. Like Benedict, he observed the norm-producing habits of Americans in the patterns inscribed by dancing, scrubbing, and painting. Of course, Warhol was not alone in his interest in the body working to achieve some normative status. There was Roy Lichtenstein's *Sponge* (1962), where the house-wife's wiping action traced a comparable motion in painting to Warhol's *Brillo Box* (fig. 19). Here, unlike the *Brillo Box*, the hand and sponge are pictured in the painting.

It seems surprising that Warhol's diagrams have very rarely been discussed in what Branden W. Joseph has termed "Warhol Studies."[48] This situation is especially odd since diagrams appear in Warhol's career-establishing exhibitions. Perhaps Warhol's diagrams have been eclipsed by the controversy that surrounded Roy Lichtenstein's diagram paintings—like *Portrait of Mme Cézanne* (1963)—taken from the painter and critic Erle Loran's *Cézanne's Composition: Analysis of His Form, with Diagrams and Photographs of his Motifs* (1941) (fig. 20).[49] Or it might be the case that War-hol's diagram paintings are too much like their counterparts—actual dance diagrams, anatomical charts, and paint-by-numbers instructions—such that to describe Warhol's diagram paintings was merely to describe their subject matter.

Of course, there are detectable differences. If Warhol had meant *Fox Trot* with its true-to-life size and its installation on the floor of the gallery to solicit a bodily (or participatory) response in the viewer, then he likewise meant *Brillo Box* to do the same. Warhol repeated, stacked, and arranged the boxes' clean and bright-white surfaces to

Fig. 19: Roy Lichtenstein, Sponge, 1962 © Estate of Roy Lichetenstein

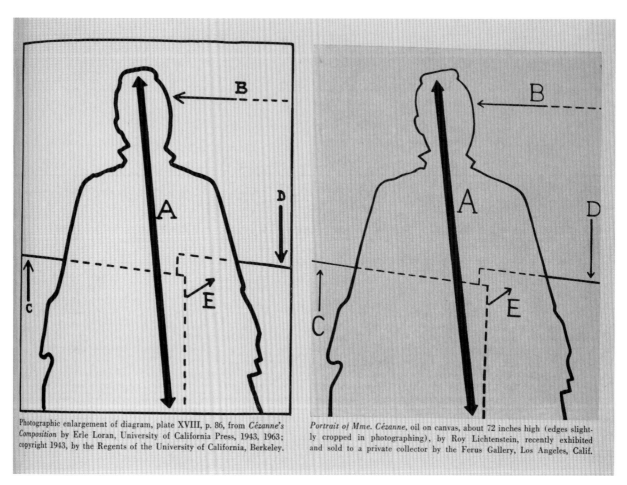

Photographic enlargement of diagram, plate XVIII, p. 86, from *Cézanne's Composition* by Erle Loran, University of California Press, 1943, 1963; copyright 1943, by the Regents of the University of California, Berkeley.

Portrait of Mme. Cézanne, oil on canvas, about 72 inches high (edges slightly cropped in photographing), by Roy Lichtenstein, recently exhibited and sold to a private collector by the Ferus Gallery, Los Angeles, Calif.

Fig. 20: Image from Erle Loran's "Pop Artists or Copy Cats?" published in Art News, 1963 Copyright © 1963 ARTnews, LLC, September

invite audience interaction. Warhol's *Brillo Boxes* work in a way that not only matched the affective qualities of Harvey's BRILLO® box's visual merchandising pattern but also increased the impact of optically aggressive qualities of the original.

By 1964, Warhol had already exhibited his diagram paintings at Eleanor Ward's Stable Gallery in 1962, and the show scheduled for the spring of 1964 was to be his last before he moved to the Leo Castelli Gallery.[50] For his final exhibition at Stable Gallery, Warhol decided to install a number of paintings and several hundred boxes like those found in the backroom storage area of any supermarket. Working in 1962, Warhol transferred his Campbell's soup-can images from the two-dimensional canvas to a three-dimensional box, simulating actual stacked cans. Unfortunately, according to Warhol, "it looked funny because it didn't look real." On one hand, it is possible that Warhol did not think that the images of cans applied to the box matched a "real" unit of stacked cans. Indeed, the lame trompe l'oeil effect that tried to approximate the shelved cans in the supermarket could have hardly fooled any viewer. Certainly, an installation of the *Campbell's Soup Box* would not have struck the likes of Arthur Danto as an instance of the ontological problem of indiscernibles. And yet, Warhol persisted in exploring the idea of reproducing the affective character of retail display within the gallery context.[51]

Abandoning his original approach to retail display, Warhol instead decided to create a series of "ordinary" boxes, the kind of packing cartons commonly used to ship supermarket products.[52] The first round of boxes were created in late 1963 and early 1964. There were three in all, which were exhibited at the Dwan Gallery in Los Angeles in February 1964. Ever committed to exploring the possibilities of format, Warhol made paintings using the image of BRILLO® box packaging.[53] Two versions of *Brillo Painting (3¢ Off)* reversed the attempts made with the *Campbell Soup Box*. In these, Warhol transferred the design of the BRILLO® box to yellow fabric. The first version repeated two panels of the box six times. The second version is a single image of two panels. Unfortunately, the results did not have the impact that

works such as *200 Soup Cans* (1962) had on the viewer. With that painting, Warhol constructed each can image from a solid red band with "Campbell's" reversed out in white, a solid yellow circle, and a white band outlined in black. "Soup" appears on the white band. Although the cans appear to be identical, they are each labeled with a different soup flavor—"tomato," "mushroom," " black bean," "vegetable," and so on— painted below "Soup." The grid composition emphasizes the horizontal alignment of the solid red bands so that there are ten red horizontal bands that dominate the painting. Each band undulates slightly at the bottom. The rows of can images also establish a point grid where the yellow circles align. Since Warhol did not pursue this approach with the BRILLO® box any further, it is safe to assume that neither version of *Brillo Painting (3¢ Off)* met with Warhol's approval. So it was back to boxes.

Rather than simply purchase or salvage several hundred cardboard boxes, Warhol decided that he should construct all of his boxes out of plywood. (He had already prepared a plywood box for his Campbell's soup-can project in 1962.) In preparation for the production of his ordinary boxes, Warhol asked Nathan Gluck to retrieve some packing cartons from the local grocery store to use as templates of a sort. As Patrick Smith has reported, Gluck, having no specific instructions as to what kind of cartons to obtain, returned to Warhol's "Factory" with several fruit crates. As Gluck recounted to Smith, pink flamingo and palm-tree motifs adorned the crates. While these boxes held some personal interest for Warhol, they were not quite what he had in mind. Thus Warhol instructed Gluck to return with boxes that were "more 'everyday.'"[54]

Warhol and his assistants measured the newly delivered cardboard BRILLO® boxes, Kellogg's Corn Flakes boxes, Heinz boxes, Del-Monte boxes, Mott's boxes, and Campbell's boxes for reproduction in plywood. Warhol sent the measurements to a professional carpenter, who manufactured plywood facsimiles to the artist's specifica-tions: 13 inches by 16 inches by 11.5 inches for Brillo-size boxes and 8.5 inches by 15.5 inches by 11 inches for Heinz-size boxes. The plywood boxes were painted with a light gray-brown house paint to match the original cardboard. The *Brillo Boxes* were the sole

exception. Warhol painted these boxes an opaque bright white. The original boxes were cut and unfolded into templates made from the long and short sides and the top flaps. The box templates were then sent to Aetna Silk Screen Products in Manhattan. There they were photographed and made into film positives. The film positives were touched up with an opaque paint and photo-offset onto screens. Aetna shipped the screens to the "Factory," where Warhol and his assistants Gerard Malanga and Billy Linich went to work silk-screening the painted plywood boxes, aligned in a grid to facilitate assembly-line production. In the case of Warhol's *Brillo Box*es, the sequence of color and image application were to begin with a painted white box and then to apply blue silk-screen ink, followed by red silk-screen ink.[55]

It is difficult to know whether Warhol had instructed Aetna to touch up the film positives. (My sense is that he did, because he wanted to produce a pristine product.) But even if he had not asked for cleaned-up versions of the original boxes, he certainly accepted the corrected, cleaner versions upon their delivery. Close inspection of the original templates reveals a good deal of dirt, scuffs, and tears that are not present on the final boxes and that correspond to the areas that were touched up in the film positives. Any marring on the surface of Warhol's boxes was a by-product of his silk-screen production and the result of his attempt to accurately reproduce the boxes that Gluck had found in the supermarket. A photograph of the 1964 Stable Gallery installation further confirms that Warhol had intended to exhibit pristine versions of the grimy original boxes (fig. 21). The photograph shows Warhol emerging from stacks of his *Brillo Box*es. His left hand is sheathed in a semitransparent rubber-latex glove—a glove that professional museum and gallery installers use to protect artworks from damage during installation. He was careful to make sure that the boxes were presented under the best possible circumstances and that the unblemished bright white of the *Brillo Box*es were set off by the dull brown of all of the remaining boxes. The care that Warhol and his assistants took when they prepared the boxes for exhibition was further enhanced by the installation of the boxes in the gallery.

Warhol's pristine boxes were in stark contrast to the marred surfaces of many of his silk-screen paintings. For example, as Hal Foster has interpreted a series of "pops" that scar the surfaces of Warhol's death and disaster paintings, *Blue Electric Chair* being one, there are instances were Warhol used clogs and streaks in the screens to represent "missed" encounters with the "real" across the canvas.[56] According to Foster, these are disruptions in the flow of images repeated over the canvas. The earliest instance of such "pops," however, was *Baseball* (1962). *Baseball* is made up of seven monochrome horizontal bands of a single photoreproduction that is screen-printed and overprinted in succession to create subtle gradations across the canvas. Just discernible is a baseball batter who is taking a hard swing. Despite the overprinting of the image and the areas where silk-screen ink clogs ("pops") the screen and mars the surface of the canvas, his smooth swinging effort is noticeable in his long stride and in the torque of his upper torso. And yet, the lines that disrupt the flow of the image interrupt the smooth swing and makes the image appear as if it is skipping across the canvas. The buildup of silk-screen ink and the juxtaposition of image transition from light to dark establishes a series of saccadic rhythms: visual scanning in quick jerks accompanied by moments of brief fixation or pools of perception. *Baseball* is an unstable image; our eyes move from one dark overprinted area to the other and then back again. The picture itself exemplifies the repetitive motion of a baseball bat swing and synchronizes saccadic rhythm and perception of a pitched ball to the swing response of the batter. But the "pops" disrupt the viewer's response, leaving him or her unable to participate in the swing; in other words, the viewer is situated so that he or she is not in the "swing" of things, much like the implied dancer in Warhol's *Fox Trot* is out of step. In the case of the *Brillo Box*es and the Stable Gallery exhibition, disruptions and disturbances occurred elsewhere.

Previously published photographs show Warhol's boxes in disarray across the floor of the Stable Gallery. Ken Heyman took a photograph during the exhibition opening; it records the crowd's disruption of the orderly appearance that Warhol planned for the

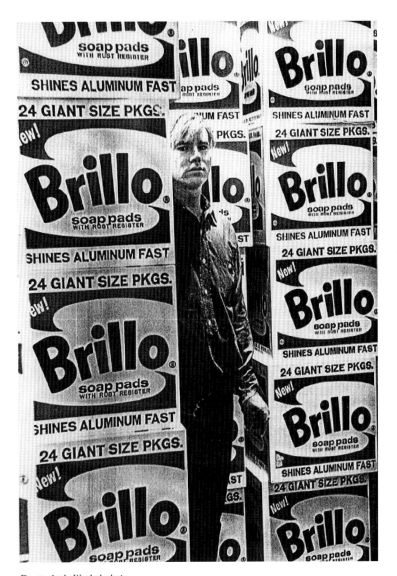

*Fig. 21: Andy Warhol photo-
graphed during Stable Gallery
installation, 1964. Archives Study
Center, Andy Warhol Museum. ©
2007 Andy Warhol Foundation for
the Visual Arts / ARS, New York.*

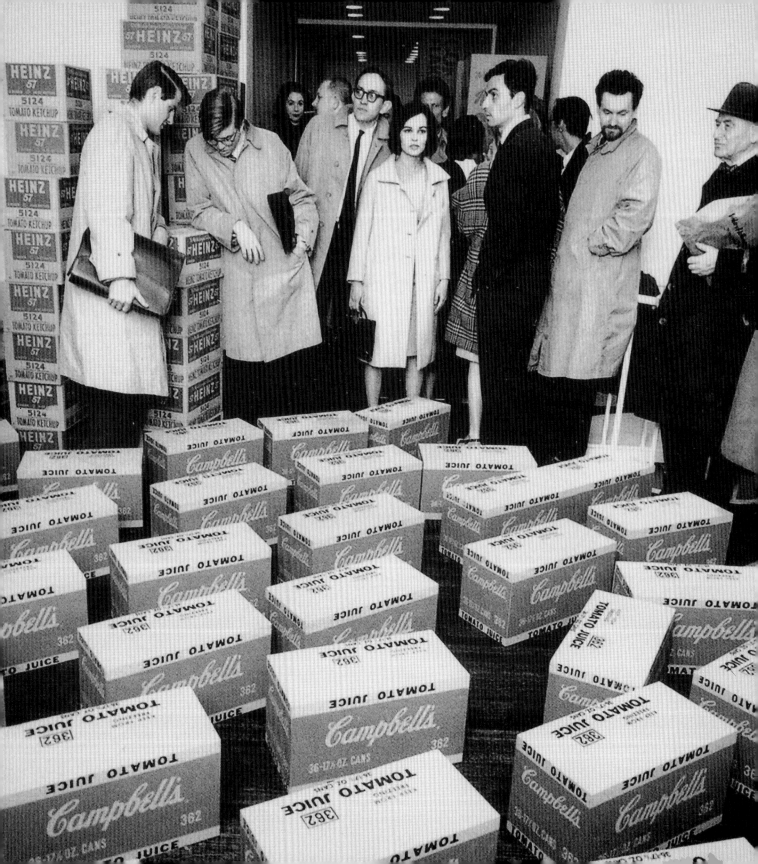

show (fig. 22). (The exhibition ran through May 9, 1964.) The photograph shows gallery visitors as they encounter hundreds of boxes stacked to varying heights near or against the walls of the gallery and ordered in rows across the gallery floor. Several boxes are out of alignment; a crowd milling among the rows of Campbell's "tomato juice" cartons disturbs the order of Warhol's installation. Occupying the middle ground with her back to the photographer, a women stands between two boxes. A man who straddles one box accompanies her. Just to the left of the couple, two men, each carrying a briefcase and wearing a trench coat, talk over a short stack of Heinz boxes. One of the two men rests his arm on the top box. The photograph supports Danto's assertion that Warhol's boxes were easily mistaken for the real thing. Certainly, the two men talking and leaning on a stack of boxes shows their lack of concern for the objects bearing their weight. The two gentlemen may very well have discussed this very point, that these objects could not be artworks. Could they? The two gentlemen were in a position to scrutinize these boxes, so that they would have been aware of their manufacture. At the very least, their close proximity would supply them with basic material facts that would lead to the observation that these were no ordinary boxes. But were they artworks? The question would not have occurred to viewers confronted with *Campbell's Soup Box* or with the two versions of *Brillo Painting (3¢ Off)*.

The pristine state of Warhol's *Brillo Box*es as they were exhibited at the Stable Gallery overemphasized the "image of cleanliness" and the rationalizing tendencies that produced modern efficiency in Harvey's BRILLO® box. Warhol's *Brillo Box*es archived the "great modern things" that were so much a part of everyday life in the American home. We could say just as much about Harvey's BRILLO® box. Harvey's box was situated within discourses on great modern things, but Warhol's *Brillo Box* took issue with these discourses as they resulted in disciplinary or normalizing behavior. So, just as *Fox Trot* made room for improvisatory action, the *Brillo Box* installation likewise opened up a space for unconstrained action. The space for spontaneous or improvisatory action can be detected in the disturbances of the boxes as they were reorganized.

Allowing the flow of viewers to jostle his neat installation, Warhol let the disruptions create an alternate pattern of culture. The unofficial "dance" of social interactions inscribed by the gallery visitors throughout the course of the exhibition were at odds with the organizing patterns inscribed by the BRILLO® box and its retail displays. This may be the case because the visitors were less interested in the art than they were in one another.

Where the arrangement of packages in the supermarket (both on the shelf and in the back room) suggests a unified visual field taken as a merchandising pattern, Warhol's scattered boxes disrupted attempts to see the exhibition as a unified whole. The diagram as a culturally specific form of *basic* representation is well suited for what Annette Michelson has argued is Warhol's interrogation of the impulse to synthesize the parts into a whole.[57] Michelson focuses almost exclusively on Warhol's "film factory," but it is diagram paintings such as *Where Is Your Rupture?* that motivated her analysis. She explains: "Warhol's parody of the film factory stands. . . as a powerful gloss on the Frankfurt analysis of the culture industry."[58] She goes on, "For Warhol [film] stars were, in Horkheimer and Adorno's phrase, 'a pattern around which the world embracing garnet is cut.'"[59] Michelson goes on to quote Adorno and Horkheimer extensively, but I am taken by the correlation that she identifies between Warhol's so-called parody of mass culture and Adorno and Horkheimer's reference to patterning in mass culture and its promotion of social and cultural "standardization."[60]

In the case of the Stable Gallery installation, the question posed by Warhol's painting *Where Is Your Rupture?* could not have been more pertinent to unpredictable impulses of social intercourse within the context of the gallery opening. No doubt, as a keen observer of social interaction, Warhol predicted the disturbance of his installation such that it wrought a gap for social action that was at odds with the *proper* conduct of behavior in the gallery. Of course, the flow of socializing men and women in the gallery was an unofficial form of behavior more common than the contemplative disinterest of the ideal visitor embodying Kant's proscription against the "private

sense" of an object gratifying his or her "through charm and emotion."[61] Here the pleasures of aesthetic experience—John Ashbery's "electrodes"—intermingled with the pleasures of the "pick up" in what Edmund Burke identified as an interest in the pleasures of beholding while seized by sexual desire and attraction. The Stable Gallery exhibition was a parody of the normative nature of the art world in that the jostled boxes resulted in a diagram of socialization that exceeded the concerns of art critics invested in a "pure" experience devoid of bodily pleasures. Perhaps this exhibition was Warhol's rejoinder to Peter Selz's criticism that Pop Art was "flaccid" and offered only "limpness."[62] A social-sexual dance was performed among all of these "great modern things" scattered around the Stable Gallery, constituting a ritual that interwove two patterns of culture. Of course, the subsequent actions that were the result of the many "hookups" at the opening were left unseen for the time being. Again, the archive remains incomplete.

5

Warhol produced his diagram paintings within a particular historical situation where, in the early 1960s, the facts of art as enjoyment (aesthetics) and the facts of capital as accumulation (economics) were very close to total reconciliation in marketing and advertising. The pressures of integration—to get in the "swing" of society—were acutely present in the visual techniques of the culture industry, and yet spontaneous action was still, at that late date, a possibility on the horizon. Later, with an imminent synthesis in view, that same horizon diminished considerably as did the returns on the mutually supporting relationship of enjoyment and accumulation. As late (and later) capitalism became triumphant and increasingly maximized its ability to "damage" our lives, Warhol's dialectical diagrams—*Fox Trot* and *Brillo Box*—were left behind as artifacts of a moment when nonrationalized and nonnormative activities could still be in the making, as it were.[63] This is their shared anthropological and archival sense. Not that *Fox Trot* and *Brillo Box* were

panaceas for the deadening logic of a rational science that was the source of many repressions, but there was in them the possibility of disrupting or interrupting the flow of normative behavior.[64] For Warhol, the diagram played both ends of the spectrum between repression and freedom, picturing the organizing tendencies of the culture industry and the critical role that artworks play in culture. Warhol's *Fox Trot* and *Brillo Box*, then, exemplified Thomas Crow's observation that "[m]ass culture is prior and determining; modernism is its effect."[65] In its wake, the global reach of late capitalism leaves us with the sense that mass culture is *all* prior, *all* determining, and *all* effect (and affect). These diagram works of Warhol, including the death and disaster series, the popular screen icons, and the superstars, anticipated an apotheosis of the culture industry. This was what made Warhol's *Brillo Box*es so important; they were archives of the concealment of the other of mass culture's systematic management of the public sphere.[66] This concealment survived as surplus in the boxes and paintings and thus constituted a refusal to concede to the disciplining pressures of the normal. It was also the case that, whatever survives in the archive, it remains incomplete in that its contents—what we can see in it—are not simply reducible to discourse. There is always some action or some thing that resists perception, description, and/or caption.

The Brillo Box Archive

In Time Capsule 5, there is a newspaper clipping for the Thursday, August 5, 1965, edition of the *New York Herald Tribune.* The aged scrap is an advertisement for a feature article in the upcoming Sunday edition of the newspaper—"Fun and Games at Warhol's Pop Art Factory." The ad is illustrated with a drawing of a Brillo box with an industrial smokestack attached to it. It appears as if it were a sketch for an actual BRILLO® box factory designed by the likes of the American architects Robert Venturi and Denise Scott Brown. (This "Pop Art Factory," however, is a design that is closer to their "decorated shed" than to their "duck.").[1] Nevertheless, the Sunday article is not in this box. Perhaps it was never published, or it found its way into one of the other Time Capsules that accumulated all of Warhol's things from 1964 to 1966. Trying to locate the missing article might prove maddening for scholars and

biographers, since one would have to search through any number of other boxes in the hopes of finding it.

Warhol claimed that he made the boxes so that he could forget their contents, so that he could forget everything. The interplay between nothing and everything and losing and finding in a short passage from Warhol's "Philosophy" constitutes a theory of the archive itself—a load off of the mind. Taking Warhol at his word, then, the boxes are memories stored only to be recovered by scholars at the Archives Study Center. In the archive, a scholar can find everything, or almost everything, that Warhol forgot. The scholar, however, never starts his or her search from a zero point of unconstructed knowledge. And the archive is an already constructed and organized object. In this it follows the norms and orthodoxies of the "archive" as an institution. Warhol's "system" disrupts this normative approach to the preservation of the past.

Weighing both the benefits and the detriments of the archive in the abstract, we might say that, on the negative side, the archive is repressive in its regulation of information. Archivists edit, organize, and limit access to material in order to preserve the integrity of the subject, organization, or institution. Archival practices imply, then, a succession of decisions that structure what the archive excludes (forgets) and includes (almost forgets). The catalog of contents offers choices after the archival fact. Rarely can the scholar discern the sequence of decisions that resulted in the contents of a particular archive. There are no maps here—unless, of course, he or she is of the mind to take the archive itself as an object of study, a document or map of sorts. But even here there are gaps. The archivist does not chart all of the territory. A series of discontinuities, elisions, and edits undermine the perceived continuity of the archive. This is the case to a great extent with the Warhol archives. Continuity in the conventional sense of the term is not the program here. Importantly, the archivist preserves the gaps and opens a space for interpretation.

It is not enough, however, to define the archive as an instance of repression. Certainly, there are ideologies in place that dictate the nature of the archive—

economic, social, and cultural to name a few. We have heard plenty of negative talk from the "museum in ruins" crowd.[2] But, rather than an account for the social construction of the archive and its preservation of ideologies rather than memories, what I am really after here is an account of what the archive produces or affords the scholar. I see this as an aspect of the gaps preserved in Warhol's archive. These gaps are akin to the cropped foot in the artist's *Fox Trot* and its disruption of the normative actions and social reproductions of dance. What I mean by what the archive "affords" are those aspects of an environment that offer possibilities for perception and action. These affordances were also present in Warhol's installation of *Brillo Boxes* at the Stable Gallery, which gave free reign to the disruptive flow of viewers. This is why, if I enumerate objectionable and unobjectionable qualities of Warhol's archive, my list tallies higher on the positive side. By my count, repression is a kind of reformation. The archive's reforming powers are therapeutic in the sense that its contents manufacture many possible senses of a subject, organization, or institution. The negative side of the list— a reckoning of the incompleteness of the archive and the ideological work that goes into filling in the gaps—informs a positivist account of the archive.

And yet, despite some initial annoyance with the seemingly arbitrary nature of Warhol's archive, feelings of excitement arise when connections are made. In addition to the clipping with the illustration of a BRILLO® box with a smokestack, Time Capsule 5 holds a white envelope that contains an announcement for Warhol's 1964 exhibition at the Stable Gallery (fig. 23). The announcement is distinctive in that it has the appearance of a tear sheet for an advertisement from a magazine. Below a head shot of Warhol is a short introduction to Warhol's exhibit, entitled "The Personality of the Artist." The art critic G. R. Swenson was responsible for both the photograph and the text of the announcement. Nowhere does Swenson actually discuss Warhol's personality per se. Instead, he remarks on the relationship between sense perception and feelings. Circumventing the artist altogether, Swenson wrote, "An understanding of the works of Angus Sinclair, the late Scottish philosopher, might be helpful in understanding

Photo & text by G. R. Swenson

THE PERSONALITY OF THE ARTIST

An understanding of the works of Angus Sinclair, the late Scottish philosopher, might be helpful in understanding the paintings and boxes of Andy Warhol, although the artist might deny it. As for Warhol's images, we ought to be wary of reading any articulated philosophy into them. If anything, these objects on canvas and store boxes speak the "language in which inanimate things speak" (the language Hofmannsthal's Lord Chandos wanted to learn). "I want to be a machine," the painter has

said, misleading many; his work does suppress those symptoms of modern art — personality and creativity — which have been sanctified to the point of blasphemy.

Art criticism has been as resistant to allowing the object to make feelings as most psychiatrists have been to allowing, for example, the head of government as a source for personal neurosis (except psychoanalytically through identification, a childhood fear of sexual authority, etc.). The

paintings and boxes of Warhol *are* feelings, as much as paint in Abstract-Expressionist painting is paint; the artist's works have almost nothing to do with his white streaked hair or his pale skin.

Sinclair, in the "Sensations, Perceptions, Feelings, Emotions and Things" chapter of *Conditions of Knowing*, states that "experiencing things and objects as things and objects is the outcome of holding certain attitudes, and to hold and apply these requires a constant effort." That suggests an

attitude to which few of us have come. Sinclair, in a footnote, suggests that we could probably develop a sensitivity to radar if it became necessary. To try to understand works of art which are not the result of personality may make us aware of an analogous need.

With a touch of prescience, Warhol's specific art has provided us with a means of seeing and feeling a place (things) which we have not seen and possibly have not sensed before.

APRIL 21 – MAY 9 OPENING 5-7, APRIL 21 STABLE GALLERY 33 EAST 74TH STREET, NEW YORK

the paintings and boxes of Andy Warhol, although the artist might deny it." He ends his brief essay thus: "With a touch of prescience, Warhol's specific art has provided us with a means of feeling a place (things) which we have not seen and possibly sensed before."[3] The organization of the artist's archive accomplishes a similar experience of surprise. Its random organization and its gaps give way to what have not been "sensed before."

This is also what *The Brillo Box Archive* endeavors to achieve—to expose that which "we have not seen and possibly sensed before." In order to accomplish this goal I worked against the grain. I did not construct a narrative that begins with Harvey's design for the BRILLO® pad shipping carton in 1961, is then resuscitated when Warhol reproduced the *Brillo Box* as artworks in his Stable Gallery exhibition in 1964, and ends that same year with Danto's "Artworld" essay. This standard chronology accounts for how one Brillo box follows another, so that each version of the Brillo box is an instance in a recollection of a series of responses, affirmations, and critiques. The logic of this narrative presumes that there exists a chain of replications in the literal sense of there being a series of mimetically repeated representations: Harvey's BRILLO® box design produces Warhol's *Brillo Box* artwork produces Danto's Brillo box thought experiment. Indeed, the objects appear in this consecutive order in their historical moment. I chose not to follow this logic. It is my contention that, like Warhol's approach to his archive, any attempt to follow an a-priori continuity in the three instances of the Brillo box belies a complex network of references in which the material and the conceptual form of the box remained the same while its status as an object changed. The range of Brillo box objects—either as philosophy, design, or art—has less to do with chronology than it does with the adaptability of the box to a range of disciplinary concerns and conceits, or what I have called practices. In no way have I reproduced the randomness of Warhol's archive. Yet I hope that I have come close to repeating its surprises.

The idea that there did not exist a sequence from one Brillo box to the other, but rather there existed instances constituting a Brillo box in philosophy, design, and art, highlights the box's transportability or mobility as an object constructed in and across

Fig. 23: Announcement for Andy Warhol exhibition at Stable Gallery, 1964. Exhibition Announcement, "The Personality of the Artist" (at Stable Gallery, New York, April 21–May 9), 1964. Founding Collection, The Andy Warhol Museum, Pittsburgh.

three distinct but related practices. This also underscores the mutability of the Brillo box's meaning, given its status as an archive. On my analysis, the archive collected its contents from the routing of references as a succession of intentions. I have borrowed the term "route of reference" from Nelson Goodman. Goodman defined reference, in a very general sense, as "covering all sorts of symbolization, all cases of *standing for*."[4] Beyond reference, Goodman's interest was in the varied relationships that can be identified between an image-sign and what it refers to, between a referent and its many inflections. This relationship was what he referred to as a "route," which indicates for me a path, a passage, or a movement that branches off in multiple directions. Considered in terms of the archive, the Brillo box was constituted within a series of innumerable instants that tracked a "route of reference" as an image-sign or symbol—in this case, Danto's "Artworld" essay, Harvey's BRILLO® box package design, and Warhol's *Brillo Box* artwork—as it moved from one disciplinary domain or practice to the other. The arrival of the Brillo box, however, could not have occurred in any one of the three fields before its design. Its arrival, although assured, inaugurated multiple routes of reference in each instance.

The Brillo box appeared where the philosopher, the designer, and the artist attempted to place the everyday in relief. For the philosopher, an investment in the everyday or the ordinary served as an analytic strategy for confronting the irreconcilable differences between experience and representation, where the former always exceeds the latter in ways that prove extraordinary. For the designer, the everyday provided a staging ground for the transformation of mere utility into a domesticated and rationalized form of perfection. In this case, it has been argued that the demands of an industrialized culture trumps that same culture's investment in free expression, but that denial is, for better or for worse, itself representative of culture. Under the purview of the everyday, culture and cultural artifacts were the product of a regimented way of thinking about the world, as had been the case in the cultural history (or the hermeneutic of worldviews) as practiced by Jacob Burckhardt and after. For the artist, the

everyday was an opportunity to rebuff the philosopher and the designer: a so-called participatory aesthetics as mass culture turned to the irreducible potential of an emancipatory aesthetics in culture. This is what Warhol meant by being able to see "commercial art as real art and real art as commercial art."[5] In all three instances, culture was certainly alienated from and alienating to the ordinary, but it was so in ways that provoked respective publics to wonder how it was that one could ever view otherwise its unfolding as a history of disciplinary techniques that resulted in social regimentation or normalization. It is precisely this confrontation with the everyday that constitutes the Brillo box archive.

NOTES

INTRODUCTION (PP. 1-19)

 1. Patrick S. Smith, *Andy Warhol's Art and Films* (Ann Arbor: UMI Research Press, 1986), nn. 24, 576. Smith refers to a clipping that he found in Warhol's scrapbooks from 1978. The clipping was from the Manhattan *Tribune*, 3 May 1969. The article discussed "Harvey's early death and Harvey's contemplation of suing Warhol."

 2. "Boxing Match," *Time*, 13 May 1964, 86.

 3. Grace Glueck, "Art Notes: Boom?" *New York Times*, 10 May 1964, 19.

 4. Jon Ruddy, "The Soap-Pad Crisis: Will It Wash?" *Toronto Telegram*, 6 March 1965, 20.

 5. J. Morris International Gallery, press release: "Department of National Revenue and National Gallery of Canada Refuse Import of Constructions by Famous U.S. Artist as Works of Art" (1965), copy in Leo Castelli Gallery records, 1958-1968, Archives of American Art, Washington, D.C.

 6. Ibid.

 7. Arthur C. Danto. *The Abuse of Beauty: Aesthetics and the Concept of Art* (Chicago: Open Court, 2003), ix.

 8. Ludwig Wittgenstein, *Philosophical Investigations,* trans. G.E.M. Anscombe (Oxford: Blackwell, 1953), 178.

 9. Wittgenstein 1953, 197. The emphasis is mine.

 10. Richard Wollheim, *Art and Its Objects,* 2d ed. (Cambridge: Cambridge University Press, 1980), 225. Although rare, some art historians have taken up Wollheim's theory,

notably Fred Orton and Charles Harrison. See Fred Orton and Charles Harrison, "Jasper Johns: 'Meaning What You See,'" *Art History* 7, no. 1 (1984): 92, and Fred Orton, *Figuring Jasper Johns* (London: Reaktion Books, 1994).

11. Orton 1994, 101.

12. Ibid., 109.

13. Harold Rosenberg, "The American Action Painters," *Art News* 51 (December 1952): 49.

14. Fred Orton states this was evidence that "there was some potential for personal revolt and for insurrection." See Orton, "Action, Revolution, and Painting," *Oxford Art Journal* 14, no. 2 (1991): 13.

15. Clement Greenberg, *Art and Culture* (New York: Beacon Press, 1961), 8.

16. Greenberg 1961, 11.

17. A friend of Harvey, the art critic Irving Sandler, recounted this story to Patrick Smith in an interview in Smith 1986, 467.

18. Arthur C. Danto, "High Art, Low Art, and the Spirit of History," in *Beyond the Brillo Box: The Visual Arts in Post-Historical Perspective* (New York: Farrar, Straus and Giroux, 1992), 154.

19. Arthur Danto, "The Artworld," *Journal of Philosophy* 61, no. 19 (October 1964): 571-84.

20. I borrow the term "epistemic culture" from Karin Knorr-Cetina. According to her, an epistemic culture determines "how we know what we know." In terms of the sciences, where knowledge "thrives" in internally referential systems, there is more diversity than previously acknowledged. Her goal is to expose the "interstitched" relations between diverse ways of knowing. See Karin Knorr-Cetina, *Epistemic Cultures: How the Sciences Make Knowledge* (Cambridge, Mass.: Harvard University Press, 1999), 1-5.

21. See Michel Foucault, "The Formation of Objects," in *The Archaeology of Knowledge* (New York: Pantheon Books, 1972), 40-49. Also, see Richard Rorty, "Foucault and Epistemology," in *Foucault: A Critical Reader,* ed. David Couzens Hoy (Oxford: Basil Blackwell, 1986), 41.

22. Michel Foucault, "Questions of Method," in *Power: Essential Works of Michel Foucault, 1954-1984,* ed. James D. Faubion (New York: New Press, 2000), 237.

23. Foucault 1972, 49.

24. Ibid.

25. Rorty 1986, 42. Ian Hacking makes a similar observation when he underscores the significance of context over authorship in Foucault's critique of the idea of a knowing subject. See Ian Hacking, "The Archaeology of Michel Foucault," in Hoy 1986, 32.

26. Ludwig Wittgenstein, *Remarks on Frazer's Golden Bough,* ed. Rush Rees (Atlantic Highlands, N.J.: Humanities Press, 1979), 16. On Wittgenstein's anthropology, see Thomas de Zengotota, "On Wittgenstein's 'Remarks on Frazer's *Golden Bough,'*" *Cultural Anthropology* 4, no. 4 (November 1989): 390-98.

27. Foucault 1972, 126-29.

28. Wollheim, "Criticism as Retrieval," in *Art and Its Objects* (Cambridge: Cambridge University Press, 1980), 185-204.

29. Jules David Prown, "Mind in Matter: An Introduction to Material Culture Theory and

Method," *Winterthur Portfolio* 17, no. 1 (spring 1982): 1. He claims, "[O]bjects made or modified by humans reflect the belief patterns of individuals who made, commissioned, purchased, or used them, and, by extension, the belief patterns of the larger society to which they belonged." Unlike Wollheim, however, Prown sees "society" as *the* horizon of inquiry.

30. See Aby Warburg, *The Renewal of Pagan Antiquity: Contributions to the Cultural History of the European Renaissance* (Los Angeles: Getty Research Institute for the History of Art and the Humanities, 1999); Erwin Panofsky, *Perspective as Symbolic Form* (New York: Zone Books, 1991); Henri Focillon, *The Life of Forms in Art* (New Haven: Yale University Press, 1942); Sigfried Giedion, *Space, Time and Architecture; the Growth of a New Tradition* (Cambridge, Mass.: Harvard University Press, 1941) and *Mechanization Takes Command, a Contribution to Anonymous History* (New York: Oxford University Press, 1948); George Kubler, *The Shape of Time: Remarks on the History of Things* (New Haven: Yale University Press, 1962); George Hersey, "Replication Replicated," *Perspecta* 10 (1965): 211–48; Robert Venturi, *Complexity and Contradiction in Architecture* (New York: Museum of Modern Art, 1966); Robert Venturi, Denise Scott Brown, and Steven Izenour, *Learning from Las Vegas: The Forgotten Symbolism of Architectural Form* (Cambridge, Mass.: MIT Press, 1977); and Whitney Davis, *Replications: Archaeology, Art History, Psychoanalysis* (University Park, Pa.: Pennsylvania State University Press, 1996).

Kubler's remarks on the "replica-mass" that "float[s] in the wake of an important work of art" are especially interesting. He writes, "The replica-mass resembles certain habits of popular speech, as when a phrase spoken upon the stage or in a film, repeated in millions of utterances, becomes a part of the language of a generation and finally a dated cliché." Kubler 1962, 39.

31. Bruno Latour, "Drawing Things Together," in *Representation in Scientific Practice,* ed. Michael Lynch and Steve Woolgar (Cambridge, Mass.: MIT Press, 1988), 45–46.

32. W. V. O. Quine, *From a Logical Point of View: 9 Logico-Philosophical Essays* (Cambridge, Mass.: Harvard University Press, 1953), 9.

33 Relevant texts are G. Frege, "On Sense and Reference" (1892), in *Translations from the Philosophical Writings of Gottlob Frege,* ed. P. Geach and M. Black (Oxford: Blackwell, 1970); Bertrand Russell, "On Denoting" (1905) and "Logical Atomism" (1924), in *Logic and Knowledge,* ed. Robert Charles Marsh (London: George Allen and Unwin, 1956); John R. Searle, "Proper Names," *Mind* 67 (1958): 166–73; Peter Thomas Geach, *Reference and Generality* (Ithaca: Cornell University Press, 1962); P. F. Strawson, "On Referring," in *Logico-Linguistic Papers* (London: Methuen and Co., 1971); Hilary Putnam, "The Meaning of 'Meaning,'" in *Mind, Language, and Reality: Philosophical Papers II* (Cambridge, Mass.: MIT Press, 1975); Gareth Evans, *Varieties of Reference* (Oxford: Oxford University Press, 1979); and Saul Kripke, *Naming and Necessity,* 2d ed. (Cambridge, Mass.: MIT Press, 1980).

34. W. V. O. Quine, *Word and Object* (Cambridge, Mass.: MIT Press, 1960), 72–79.

35. Bruno Latour, *Pandora's Hope: Essays on the Reality of Science Studies* (Cambridge, Mass.: Harvard University Press, 1999), 58.

36. J. L. Austin, *How to Do Things with Words* (Cambridge, Mass.: Harvard University Press, 1962), 4.

37. Knorr-Cetina 1999, 5.

38. Pat Hackett and Andy Warhol, *Popism: The Warhol '60s* (New York: Harcourt Brace Jovanovich, 1980), 4.

39. Clement Greenberg defines Jasper Johns's Flag painting as "homeless representations." See "After Abstract Expressionism," *Art International* 6 (25 October 1962): 25-27.

40. Andy Warhol, *The Philosophy of Andy Warhol (from A to B and Back Again)* (New York: Harcourt Brace Jovanovich, 1975), 145.

ARCHIVE 1: AESTHETICS (PP. 21-49)

1. Arthur Danto, "The Artworld," *Journal of Philosophy* 61, no. 19 (October 1964): 580.

2. Arthur C. Danto, preface to *Philosophizing Art: Selected Essays* (Berkeley: University of California Press, 1999): xi.

3. Arthur C. Danto, "Description and the Phenomenology of Perception," in *Visual Theory: Painting and Interpretation,* ed. Michael Ann Holly, Norman Bryson, and Keith Moxey (Cambridge: Polity Press, 1991), 204. For Danto's account of the historical nature of vision, see Arthur C. Danto, "Seeing and Showing," *The Journal of Aesthetics and Art Criticism* 59, no. 1 (winter 2001): 1-10.

4. See Lewis's account of the importance of Kant having taken "skeptical doubt seriously." C. I. Lewis, "Logic and Pragmatism," in *Collected Papers* (Stanford: Stanford University Press, 1970).

5. Arthur C. Danto, *After the End of Art: Contemporary Art and the Pale of History* (Princeton: Princeton University Press, 1997), 199-200, and *Connections to the World: The Basic Concepts of Philosophy* (Berkeley: University of California Press, 1989), 242-48.

6. Immanuel Kant, *Critique of Judgment,* trans. Werner S. Pluhnar (Indianapolis: Hackett Publishing, 1987), sec. 6.

7. On the linguistic turn in Kant, see Paul Guyer, *Kant and the Claims of Taste* (Cambridge: Cambridge University Press, 1997), 119-20.

8. On Danto's "historicist" (or Hegelian) response to Kantian aesthetics, see Paul Guyer's review of Danto's *The Philosophical Disenfranchisement of Art.* Paul Guyer, "When Is Black Paint More than Black Paint? *New York Times Book Review* (February 1, 1987), 23.

9. Arthur C. Danto, interview with author, February 22, 2000. Certainly, there were other instances where critics were confronted with similar perceptual challenges. For example, Sidney Tillim recounted being taken in by shelves of replicas of mass consumables upon entering Claes Oldenburg's "The Store," an installation in his storefront studio at 107 East Second Street in Manhattan. To whatever extent they were mimetic, Oldenburg's enticements were not deceptive. He wrote, "Oldenburg made no effort to reproduce each item faithfully. The likenesses varied, for on the principle of caricature the color and tactile properties of each object were exaggerated, though usually natural scale was retained." Sidney Tillim, "from Month in Review: New York Exhibitions," *Art International* (March 1962): 35-36.

10. Gregg Horowitz and Tom Huhn, eds., *The Wake of Art: Criticism, Philosophy, and the Ends of Taste* (Amsterdam: Overseas Publishers Association, 1998), 7.

11. There are numerous critical evaluations of Pop Art, but these have little if any

relevance to the question of the acuteness of perception. The texts that I discuss in this section deal with New Realist and Pop artworks as they were situated within discourses on perception and ontology. These are less concerned with style than they are with the affective nature of artworks. The list of critical texts on Pop Art and New Realism is too long to reproduce here. However, for an excellent collection of vital texts, see Madoff 1997.

12. Danto 1964, 573.

13. Ibid.

14. Ibid., 574.

15. Arthur C. Danto, "Artworks and Real Things," *Theoria* 39 (1973), 4. This essay was Danto's second installment in his pursuit of his philosophy of art, a pursuit that eventually resulted in his *The Transfiguration of the Commonplace.*

16. Danto 1964, 575.

17. Arthur C. Danto, *The Transfiguration of the Commonplace: A Philosophy of Art* (Cambridge, Mass.: Harvard University Press, 1981), vii.

18. Roger Fry considered the shift from the Impressionist view to the Post-Impressionist view to have been a result of the feeling that the Impressionists were "too naturalistic." Impressionism was therefore still involved with the long-standing project of imitation as a proper mode of pictorial representation. Imitation necessarily required the interpretation of paintings based on their subject matter rather than on their formal, material qualities. Roger Fry, *Manet and the Post-Impressionists* (London: Ballantyne and Company, 1910), 7.

19. See Daniel Herwitz, *Making Theory/Constructing Art: On the Authority of the Avant-Garde* (Chicago: University of Chicago Press, 1993), 233.

20. See Paul Mattick, "The Andy Warhol of Philosophy and the Philosophy of Andy Warhol," *Critical Inquiry* 24 (summer 1998): 966–72.

21. And, as Horowitz and Huhn have remarked, that from this Danto "crafted a *philosophical* defense of the *philosophical pointlessness* of taste and aesthetic judgment." See Horowitz and Huhn 1998, 7.

22. Danto 1989, 6-8.

23. Danto 1999, 63. The article was originally published in Arthur C. Danto, "The Philosopher as Andy Warhol," in *The Andy Warhol Museum* (Pittsburgh: Andy Warhol Museum, 1994).

24. Art history has yet to acknowledge Danto's place in the history of post–World War II art in the United States. Caroline Jones is one of the few art historians to do so. Caroline A. Jones, *Machine in the Studio: Constructing the Postwar American Artist* (Chicago: University of Chicago Press, 1996), 143, 334, and Caroline A. Jones, "The Modernist Paradigm: The Artworld and Thomas Kuhn," *Critical Inquiry* (spring 2000): 516. Danto's contribution, and by extension Warhol's contribution, to philosophical aesthetics is extensive. While a list of critical responses would be unmanageably long, several key texts are Horowitz and Huhn 1998; David Carrier, ed., *Danto and His Critics: Art History, Historiography, and After the End of Art* (Middletown, Conn.: Wesleyan University Press, 1998); and Mark Rollins, ed., *Danto and His Critics* (Oxford: Blackwell, 1993).

25. Danto 1964, 580.

26. Ibid., 581.

27. Danto 1981, 208.

28. Danto 1997, 77.

29. Ibid.

30. Clement Greenberg, "Avant Garde and Kitsch," in *Art and Culture* (Boston: Beacon Press, 1961), 5. "Avant Garde and Kitsch" was originally published in *Partisan Review* in the Fall of 1939. I cite the 1960s revised version of the article because that was the version readily available to Greenberg's critics at the time.

31. Wittgenstein's lectures and informal talks are the basis for his *Philosophical Investigations,* published in 1953. His students' notes from the lectures and talks were later transcribed and published as *The Blue and Brown Books.* See Ludwig Wittgenstein, *Philosophical Investigations,* trans. G. E. M. Anscombe (Oxford: Blackwell, 1953), and *The Blue and Brown Books* (New York: Harper Torch Books, 1958).

32. Wittgenstein 1953, 193.

33. Ibid.

34. Ibid.

35. David Levin has observed of Wittgenstein's "seeing-as," "The logic of the 'as'-structure is a logic, in this sense, of violence." Nowhere does Levin account for this violence, but it would seem that he is tuned into the aspectual manipulations, or the way that descriptions make the world malleable, in Wittgenstein's account of "seeing-as." If such violence exists, then it is tempered by Wittgenstein's shift to "seeing-in," as it was taken up by Wollheim and as I discussed in the introduction. See David Michael Levin, *The Philosopher's Gaze: Modernity in the Shadows of Enlightenment* (Berkeley: University of California Press, 1999), 106.

36. T. E. Wilkerson, "Seeing-As," *Mind* 82, no. 328 (1973): 481–96, and Malcolm Budd, "Wittgenstein on Seeing Aspects," *Mind* 96, no. 381 (1987): 1–17.

37. Wittgenstein 1953, 196.

38. Wittgenstein 1958, 168–69.

39. As a policy for the exhibition, the jurors were to accept any object, but, as Louise Norton reports, "the jurors of The Society of Independent Artists fairly rushed to remove the bit of sculpture called *Fountain* sent in by Richard Mutt, because the object was irrevocably associated in their atavistic minds with a certain natural function of a secretive sort." Despite the jurors' initial rejection, *Fountain*'s place within the modernist canon of art has long been established. See Louise Norton, "Buddha of the Bathroom," *The Blind Man* 1, no. 2 (1917), n.p.

40. George Dickie, *Art and Aesthetics: An Institutional Analysis* (Ithaca: Cornell University Press, 1974). Danto maintains that Dickie's "Institutional Theory of Art" is "quite alien to any thing I believe." Danto 1981, viii.

41. Danto discussed Goodman in Danto 1981, 72–74.

42. Danto 1964, 581.

43. Arthur C. Danto, "Aesthetics of Andy Warhol," in *Encyclopedia of Aesthetics,* ed. Michael Kelly (New York: Oxford University Press, 1998), 41.

44. Arthur C. Danto, "High Art, Low Art, and the Spirit of History," in *Beyond the Brillo Box: The Visual Arts in Post-Historical Perspective* (New York: Farrar, Straus and Giroux, 1992), 154.

45. Peter Selz, "A Symposium on Pop Art (Special Supplement)," *Arts Magazine* (April 1963): 43. The emphasis is mine.

46. Kramer in ibid., 38.

47. Geldzahler in ibid., 37.

48. Steinberg in ibid., 40.

49. Selz 1963, 43.

50. The quote is from Edward Bullough, "'Psychical Distance' as a Factor in Art and an Aesthetic Principle," *British Journal of Psychology* 5 (June 1912), 42. Selz quoted Bullough in his "Aesthetic Theories of Wassily Kandinsky and Their Relationship to the Origin of Non-Objective Painting," *The Art Bulletin* 39 (June 1957): 130.

51. Steinberg in Selz 1963, 40.

52. Herbert Marcuse, *Eros and Civilization; a Philosophical Inquiry into Freud* (Boston: Beacon Press, 1955), 183.

53. Ibid., 181.

54. Ibid.

55. Ibid., 176.

56. Meyer Schapiro, "Recent Abstract Painting," in *Modern Art, 19th and 20th Centuries: Selected Papers* (New York: George Braziller, 1978), 222.

57. John Ashbery, "The New Realism," in *New Realists* (New York: Sidney Janis Gallery, 1962), n.p.

58. See Emil du Bois-Reymond, *Untersuchungen über thierische Elektricität* (Berlin: G. Reimer, 1848); Gustav Fechner, *Elemente der psychophysik* (Leipzig: Breitkopf und Hartel, 1860); and Hermann Von Helmholtz, *Handbuch der physiologischen Optik* (Leipzig: L. Voss, 1867).

59. Henry Rutgers Marshall, *Pleasure, Pain, and Aesthetics: An Essay Concerning the Psychology of Pain and Pleasure, with a Special Reference to Aesthetics* (London: Macmillan, 1894), 347. "Hedonics" or "Physiological Aesthetics" was a nineteenth-century physiological model of aesthetic experience put forth by Marshall and the British writers Grant Allen and James Sully. For more on "Physiological Aesthetics" and "Hedonic criticism," see Michael Golec, "Andy Warhol and New Realism," Ph.D. diss. (Northwestern University, 2003), 160-67.

60. Walter Benjamin, "Surrealism: The Last Snapshot of the European Intelligentsia," in *Walter Benjamin: Selected Writings,* vol. 2, part 1, *1927-1930,* ed. Michael W. Jennings, Howard Eiland, and Gary Smith (Cambridge, Mass.: Belknap Press of Harvard University Press, 1999), 207.

61. Alan R. Soloman, "The New American Art," *Art International* 8, no. 2 (March 1964): 52.

62. My account of a viewer's journey to *Blue Electric Chair* is derived from photographs of the Sonnabend Gallery installation. Time Capsule 39, Archives Study Center, Andy Warhol Museum, Pittsburgh, Pa.

63. John Ashbery in *Warhol* (Paris: Ileana Sonnabend Gallery, 1964), n.p. Ashbery's essay is in French. The translation here is mine. The original reads: "*Andy Warhol nous ramène au mode visible. Mais, ce faisant, ses récents tableaux macabres dressent de nouveaux obstacles*

devant nos yeux. Ce n'est pas tant que le regard ne puisse y embrasser tout à la fois, c'est que les choses ont été infectées au départ."

64. Nelson Goodman, *Languages of Art: An Approach to a Theory of Symbols* (Indianapolis: Hackett Publishing, 1968), 81–85.

65. David Summers, "Real Metaphor: Towards a Redefinition of the Conceptual Image," in *Visual Theory: Painting as Interpretation,* ed. Michael Ann Holly, Norman Bryson, and Keith Moxey (New York: HarperCollins, 1991), 145–46.

66. Even Kant, the philosopher of disinterest, acknowledged the currency of a homeopathic dose of reality. According to Howard Caygill, Kant's *Critique of Judgment* allowed a shift from a "corporeal model of consciousness" to a "representational model of consciousness." See Howard Caygill, "Life and Aesthetic Pleasure," in *The Matter of Critique: Readings in Kant's Philosophy,* ed. Andrea Rehberg and Rachel Jones (Manchester: Clinamen Press, 2000), 79.

67. Caygill 2000, 84. Like Caygill, Hubert Damisch has puzzled over "the enigma of pleasure" in Kant's *Critique of Judgment,* but he has done so with the aid of Freudian psychoanalysis: "How can we have a 'feeling of life' so utterly unconnected to desire that the subject can properly pay no attention to the existence of an object whose representation is a source of pleasure for it?" He has answered that we cannot have "'feeling of life'" unconnected to desire and pleasure. No doubt there existed a libidinal dimension to the physiological aesthetic experience of Warhol's electric-chair paintings, a dimension that further complimented and complicated its intelligibility. See Hubert Damisch, *The Judgment of Paris* (Chicago: University of Chicago Press, 1996), 43.

68. Susan Sontag, *Against Interpretation and Other Essays* (New York: Delta, 1966), 13. Originally published as "Against Interpretation," *Evergreen Review* 8, no. 34 (December 1964): 76–80, 93.

69. Sontag 1966, 11.

70. Ibid., 10

71. Ibid., 14.

72. Ibid., 288.

73. Ibid., 14.

74. Edmund Burke, *A Philosophical Enquiry into the Origin of Our Ideas of the Sublime and Beautiful,* ed. J. T. Boulton (London: Routledge and Kegan, 1958), 42. For Burke, the appreciations or aesthetic pleasure taken in beautiful things is biologically motivated.

75. Sontag 1966, 5.

76. Ibid.

77. Ibid., 12. Sontag's comments were reminiscent of Leonard Meyer's definition of "radical empiricism" in the arts. "For the radical empiricist," he wrote, "the isolated object freshly experienced is the chief source of value." Meyer further contended that the artist and critic were interested in things as they are, both adopting a "primitive" delight in the world as it "simply is." Leonard B. Meyer, "The End of the Renaissance? Notes on the Radical Empiricism of the Avant-Garde," *Hudson Review* 16, no. 2 (summer 1963): 177, 179–80. In his interview with Gene Swenson, Warhol referred to Meyer's article, stating, "It was about [John]

Cage and the whole crowd, but with a lot of big words like radical empiricism and teleology." Warhol in G. R. Swenson, "What is Pop Art?" *Art News* (November 1963): 60. While there were correspondences between Sontag and Meyer's text, Sontag explicitly cited Pop Art, and Meyer attended to what we might consider to be pre-Pop artists such as John Cage and Robert Rauschenberg.

78. Sontag 1966, 13.

79. Ibid., 36. Originally published as "On Style," *Partisan Review* 32 (1965): 543-60.

80. Ibid., 9. Sontag's essay closely resembled the French literary critic Roland Barthes' essay on the literary realism of Alain Robbe-Grillet. Barthes was a critic that Sontag continually referred to in her early essays. See Roland Barthes, "The Last Word on Robbe-Grillet?" in *Critical Essays,* trans. Richard Howard (Evanston: Northwestern University Press, 1972), 197. See also Roland Barthes, *Writing Degree Zero* (New York: Hill and Wang, 1968), 71, and Susan Sontag, preface to Barthes 1968, xvi.

81. Sonya Rudikoff, "New Realists in New York," *Art International* 7 (January 1963): 39. See also Gilbert Sorrentino, "Kitsch into 'Art': The New Realism," *Kulchur* 8, no. 2 (winter 1962): 10-23.

82. Rudikoff 1963, 40.

83. Ibid., 41.

84. Ellen H. Johnson, "The Image Duplicators — Lichtenstein, Rauschenberg and Warhol," *Canadian Art* 23 (January 1966): 15.

85. Ibid. For a negative appraisal of the relationship between New Realism and advertising, see Sorrentino 1962, 10-23. Sorrentino followed Clement Greenberg when he described the objects found in the New Realists exhibition as being the product of American corporate-style marketing.

86. Danto 1964, 581.

87. Danto 1992, 5.

88. Danto 1981, 208.

89. Danto 1999, 5.

90. For a counterargument on the imagination's or the philosophical thought experiment's lack, see Elaine Scarry, "On Vivacity," in *Dreaming by the Book* (New York: Farrar, Straus and Giroux, 1999), 3-9. In opposition to the perceptual poverty of the imagination, Scarry claims, "Imagining is an act of perceptual mimesis, whether undertaken in our daydreams or under the instruction of great writers. And the question is: how does it come about that this perceptual mimesis, which when undertaken on one's own is ordinarily feeble and impoverished, when under authorial instruction sometimes closely approximates actual perception?" (6).

91. Arthur C. Danto, *Connection to the World: The Basic Concepts of Philosophy* (Berkeley: University of California Press, 1997), 8. David Carrier has written on Descartes' influence on Danto's theories of action, history, and art. David Carrier, "Danto as a Systematic Philosopher or *comme on lit Danto en français,*" in Rollins 1993, 17.

92. René Descartes, *Discourses on Method and Meditations,* trans. Laurence J. Lafleur (Indianapolis: Bobbs-Merrill, 1960), 76.

93. Stanley Cavell, "The Avoidance of Love: A Reading of King Lear," in *Must We Mean What We Say? A Book of Essays* (Cambridge: Cambridge University Press, 1969), 323.

94. Stanley Cavell, *The Claim of Reason: Wittgenstein, Skepticism, Morality, and Tragedy* (New York: Oxford University Press, 1979), 131.

95. Stanley Cavell, *The World Viewed: Reflections on the Ontology of Film* (Cambridge, Mass.: Harvard University Press, 1971), 102.

96. Ibid., 8.

97. Richard Rorty, ed., *The Linguistic Turn: Recent Essays in Philosophical Method* (Chicago: University of Chicago Press, 1967), and *Philosophy and the Mirror of Nature* (Princeton: Princeton University Press, 1979).

98. Ian Hacking, *Why Does Language Matter to Philosophy?* (Cambridge: Cambridge University Press, 1975): 182. See Rorty's review of Hacking's book, "Ten Years After," included in the second edition of the *Linguistic Turn* (1977): 361–70.

99. For an account on the influence of Pop Art and the linguistic turn in philosophy on architecture, see Aron Vinegar and Michael J. Golec, "Introduction," in *Instruction and Provocation; or, Relearning from Las Vegas,* ed. Aron Vinegar and Michael J. Golec (Minneapolis: University of Minnesota Press, 2008).

100. Wittgenstein also said, as if anticipating Danto's presence in front of Warhol's *Brillo Box,* "Naming appears as a queer *connexion* of a word with an object.—And you really get such a queer connexion when the philosopher tries to bring out the relation between name and thing by staring at an object in front of him and repeating a name or even the word 'this' innumerable times." Wittgenstein 1953, sec. 38.

ARCHIVE 2: DESIGN (PP. 51–80)

1. Danto made this observation when considering the ontological problems present in Jorges Luis Borges's "Pierre Menard, Author of the *Quixote.*" The same observation, however, stood for Warhol's *Brillo Box,* as well. See Arthur C. Danto, *The Transfiguration of the Commonplace: A Philosophy of Art* (Cambridge, Mass.: Harvard University Press, 1981), 33–36. See Jorge Luis Borges, "Pierre Menard, Author of the *Quixote,*" in *Labyrinths: Selected Stories and Other Writings* (New York: New Directions, 1964), 36–44.

2. Danto 1981, 156.

3. http://www.brillo.com/crelations/history.asp. BRILLO® pads were patented in 1913, the pad and the soap were separate.

4. See the brief article on Stuart and Gunn in the special issue "Design in New York," *Industrial Design* 7, no. 10 (October 1960): 71.

5. For an account of the critical reception of Pop Art and why "the difference between Pop-art expert and shopper no longer could be drawn with much clarity," see Cécile Whiting, *A Taste for Pop: Pop Art, Gender, and Consumer Culture* (Cambridge: Cambridge University Press, 1997), 48. For Warhol's *Brillo Box*es and their influence on a revision of the criteria of aesthetic judgment, see Arthur C. Danto, "The Artworld," *Journal of Philosophy* 61 (15 October 1964): 571–84; Danto 1981; *Beyond the Brillo Box: The Visual Arts in Post-Historical*

Perspective (New York: Farrar, Straus and Giroux, 1992); and *The Abuse of Beauty: Aesthetics and the Concept of Art* (Chicago: Open Court, 2003).

6. See Michelle Bogart's excellent *Artists, Advertising, and the Borders of Art* (Chicago: University of Chicago Press, 1995).

7. There exist Clement Greenberg's all-too-familiar gripes in "Avant-Garde and Kitsch." Also, there is the idea that the advent of mechanical reproduction (or photomechanical reproduction), according to Walter Benjamin's "The Work of Art in the Age of Mechanical Reproduction," first published in 1936, allowed for radically new representations of the world. But, Benjamin warned, with the technological advances of lenses, shutters, films, and presses there was an equivalent occurrence of *depreciation*. And in 1944, Theodor Adorno and Max Horkheimer damned the culture industry and the manner in which mass culture gives the illusion of liberation while at the same time it restricts the cultural potential of actual activities that constitute liberation or personal freedom. See Walter Benjamin, "The Work of Art in the Age of Mechanical Reproduction," in *Illuminations: Essays and Reflections,* ed. Hannah Arendt (New York: Schocken Books, 1968); and Max Horkheimer and Theodor Adorno, *Dialectic of Enlightenment,* trans. John Cumming (New York: Seabury Press, 1972).

8. As I discuss in the introduction, an article in *Time* first mentioned a possible suit. See "Boxing Match," *Time,* 13 May 1964, 86. Also see Grace Glueck, "Art Notes: Boom?" *The New York Times,* 10 May 1964, 19.

9. Harvey also exhibited at the Graham Gallery in Manhattan and at Gertrude Kasle in Detroit.

10. The filmmaker Emile de Antonio best expressed this attitude when he explained to Andy Warhol that Robert Rauschenberg and Jasper Johns were offended by, among other things, his acquiescence to commerce. De Antonio remarked, "you're a commercial artist, which really bugs them because when they do commercial art . . . they do it just 'to survive.'" De Antonio's remark implied that artists pursuing other means of employment besides fine-art production should not make such compromises public, nor should they enjoy the pursuit of such commercially driven ends. See Warhol and Hackett 1980, 12. This passage is quoted in Kenneth E. Silver, "Modes of Disclosure: The Construction of Gay Identity and the Rise of Pop Art," in *Hand-Painted Pop: American Art in Transition, 1955–62,* ed. Russell Ferguson (New York: Rizzoli International, 1992): 197. I am mindful of the complexities of this passage, especially its suggestion that commercial work was less than manly work. Silver quotes from Warhol's conversation with de Antonio to make the point that the artist's interest in consumption "transgressed his proper gender identification." Silver interprets Warhol's introduction of commercial art into the realm of high art as public identification with gay culture. See Silver 1992, 197–201.

11. William Rubin, "Younger American Painters," *Art International* 4 (January–February 1960): 25. Quoted in Whiting 1997, 128. Whiting argues that Rubin viewed the second-generation Abstract Expressionists as exemplary of a "crisis of masculinity."

12. As Michelle Bogart has explained, in the early 1960s "an artist might stick to his brushes and thus likely become marginal to society, or he could become a commercial artist, earning some approval and a decent living." See Bogart 1995, 298.

13. Kenneth Frampton, "Towards a Critical Regionalism: Six Points for an Architecture of Resistance," in *The Anti-Aesthetic: Essays on Postmodern Culture,* ed. Hal Foster (Port Townsend, Wash.: Bay Press, 1983), 20.

14. Kenneth Ames has used "tangible proof" to describe his method of examining the "unspoken assumptions and persuasions of everyday life through the things that framed and gave meaning to that life." See his *Death in the Dining Room and Other Tales of Victorian Culture, American Civilization* (Philadelphia: Temple University Press, 1992), 1. As a source for his use of the term, Ames cites Simon J. Bronner, "Visible Proofs: Material Culture Study in American Folkloristics," in *Material Culture: A Research Guide,* ed. Thomas J. Schlereth (Lawrence: University Press of Kansas, 1985).

15. During the 1930s, BRILLO® ads stated, "The MODERN Way of Cleaning Aluminum and Other Utensils." For example, see BRILLO® ad in *Woman's Home Companion,* November 1933, 116.

16. Adrian Forty, *Objects of Desire* (New York: Pantheon Books, 1986), 156.

17. Maiken Umbach and Bernd Hüppauf, "Introduction: Vernacular Modernism," in *Vernacular Modernism: Heimat, Globalization, and the Built Environment,* ed. Maiken Umbach and Bernd Hüppauf (Stanford: Stanford University Press, 2005).

18. *Bulletin of the Art Institute,* September–October 1947, n.p. Harvey graduated from the School of the Art Institute with a four-year diploma in 1951. He received a B.F.A. from there in 1953.

19. Barbara Jaffee, "Before the New Bauhaus: From Industrial Drawing to Art and Design Education in Chicago," *Design Issues* 21, no. 1 (winter 2005): 57.

20. I take the term from Robert Trent, *Hearts and Crowns: Folk Chairs of the Connecticut Coast, 1720–1840, as Viewed in the Light of Henri Focillon's Introduction to Art Populaire* (New Haven: New Haven Colony Historical Society, 1977), 25. Trent performs an analysis of the "turned-chair" made between 1720 and the 1800s to establish a baseline for further analysis and comparison of the variety of forms that constitute the Heart and Crown tradition.

21. Reprinted in Carma Gorman, *The Industrial Design Reader* (New York: Allworth Press, 2003), 173.

22. Karal Ann Marling, "Nixon in Moscow: Appliances, Affluence, and Americanism," in *As Seen on TV: The Visual Culture of Everyday Life in the 1950s* (Cambridge, Mass.: Harvard University Press, 1994), 243.

23. See Frederick C. Barghoorn, "America in 1959: As Seen from Moscow," *The Review of Politics* 22, no. 2 (April 1960): 252.

24. Marling claims that this example of "political theatre" was "carefully staged." Marling 1994, 277.

25. Saul Bass, "Design of Shipping Containers," in *Packaging, Packungen, Emballages: An International Survey of Package Design,* ed. Walter Herdeg (Zurich: Amstutz and Herdeg, 1959), 224.

26. Ann Ferebee, "Memorable Packages," *Industrial Design* 7, no. 7 (July 1960): 31.

27. Ann Ferebee, "Should Suppliers Offer Design Services?" *Industrial Design* 8, no. 4 (April 1961): 57. See also Pulos 1988, 280-283.

28. Walter Dill Scott, *The Psychology of Advertising* (New York: McBride, 1932), 45.

29. Rachel Bowlby, *Shopping with Freud* (London: Routledge, 1993), 96.

30. Walter Dill Scott, *The Theory of Advertising: A Simple Exposition of the Principles of Psychology in Their Relation to Successful Advertising* (Boston: Small, Maynard and Company, 1903), 232.

31. Scott 1903, 159.

32. Susan Sontag, *Against Interpretation and Other Essays* (New York: Delta, 1966), 288.

33. On Wundt's influence, see Jonathan Crary, *Suspensions of Perception: Attention, Spectacle, and Modern Culture* (Cambridge, Mass.: MIT Press, 2000), 29.

34. See my brief discussion of reflex-arc theories in Archive 1.

35. On the importance of eidetic imagery to Wundt's project, see George Kubler, "Eidetic Imagery and Paleolithic Art," *The Journal of Psychology* 119, no. 6 (1985): 559.

36. Paul Roazen, *Freud: Political and Social Thought* (New York: Alfred A. Knopf, 1968), 232-34. Also see Paul Roazen, *Encountering Freud: The Politics and Histories of Psychoanalysis* (New Brunswick: Transaction Publishers, 1990), 139-60.

37. The issue of image as playing a role in ego formation is a constant theme throughout Erikson's career. See especially Erik H. Erikson, "Children's Picture Books," in *A Way of Looking at Things: Selected Papers of Erik H. Erikson, 1930-1980*, ed. Stephen P. Schlein (New York: W. W. Norton, 1987), 33-34. The paper was originally delivered at the House of Children, Vienna, in 1930 and published in *Zeitschrift für Psychoanalytische Pädagogik* 5 (1931): 13-19.

38. See especially chapter 1 in Paul Schilder, *The Image and Appearance of the Human Body; Studies in the Constructive Energies of the Psyche* (New York: International Universities Press, 1950). The book was originally published in 1935.

39. Ibid., 16.

40. Paul Schilder, *Psychoanalysis, Man, and Society* (New York: W. W. Norton, 1951), 37. The paper was given in 1933 and published in the *Journal of Abnormal and Social Psychology* 29 (1934): 314-27.

41. On the relationship between Aufbau and psychoanalysis, see Nathan G. Hale, Jr., *The Rise and Crisis of Psychoanalysis in the United States: Freud and the Americans, 1917-1985* (New York: Oxford University Press, 1995), 321-32.

42. Ibid., 232.

43. Harry Trosman, "*Essays on Ego Psychology: Selected Problems in Psychoanalytic Theory* (Review)," *The American Journal of Sociology* 71, no. 5 (March 1966): 587.

44. Schilder 1951: 9.

45. Ibid., 333.

46. Heinz Hartmann, *Ego Psychology and the Problem of Adaptation*, trans. David Rapaport (New York: International Universities Press, 1964), 24. Hartmann first delivered his paper "Ich-Psychologie und Anpassungsproblem" in 1937 and published it in 1939.

47. Ibid., 25.

48. Ibid., 58.

49. Peter Galison has discussed the parallel and interrelated developments of the Vi-

enna School's logical positivists (namely Rudolf Carnap and Otto Neurath) and the Bauhaus. He has revealed the correspondence between Bauhausian notions of building coherent forms from primary shapes and colors and the logical-positivist creation of logical propositions from singular components of raw experiences. See Peter Galison, "Aufbau/Bauhaus: Logical Positivism and Architectural Modernism," *Critical Inquiry* 16 (summer 1990): 709–52.

50. Gyorgy Kepes, *Language and Vision* (Chicago: Paul Theobald, 1944).

51. Ibid., 200. Kepes's "reintegration" echoed John Dewey's thoughts on how perception is a mode of re-creation. Dewey wrote, "Without the act of recreation the object is not perceived as a work of art." John Dewey, *Art as Experience* (New York: Capricorn Books, 1958), 54.

52. Felix Deutsch, "Body, Mind, and Art," in *The Visual Arts Today,* ed. Gyorgy Kepes (Middletown, Conn.: Wesleyan University Press, 1960), 38.

53. Ibid., 39.

54. E. H. Gombrich, "On Physiognomic Perception," in Kepes 1960, 237.

55. E. H. Gombrich, *Art and Illusion; a Study in the Psychology of Pictorial Representation* (New York: Bollingen Foundation, 1960), 28–29.

56. Gombrich's use of a page from Frederik de Wit's *Lumen picturae et delinationes* (Amsterdam, ca. 1660) for the frontispiece of *Art and Illusion* demonstrated the complex role of the image in staging the comportment of the body and its representation. With the de Wit etching, Gombrich showed that the image was a copy of the body and the body was a copy of the image. Such a mimetic correlation, however, need not have always been the case. See also Kaja Silverman's discussion of Wallon and Schilder in her "Speak, Body," *Discourse* 22, no. 2 (spring 2000): 14–15. Silverman reproduced a film still from the Viennese filmmaker and performance artist Valie Export that is strikingly similar to the frontispiece of Gombrich's book.

57. Kepes 1944, 14.

58. Gyorgy Kepes, "The Creative Discipline of Our Visual Environment," *College Art Journal* 7, no. 1 (1947): 19. Also see Gyorgy Kepes, "The Importance of Order in Vision," in *Building for Modern Man,* ed. Thomas Hawk Creighton (Princeton: Princeton University Press, 1949).

59. Kepes 1944, 221.

60. Paul Rand, "Advertisement: Ad Vivum or Ad Hominem," in Kepes 1960, 132.

61. The term "interest incentives" is Scott's (Scott 1913, 43). The issues of affect and response, first established by Scott, remain the principal concerns of the psychology of advertising. Recent published studies include Linda M. Scott and Rajeev Batra, eds., *Persuasive Imagery: A Consumer Response Perspective* (Mahwah, N.J.: Lawrence Erlbaum Publishers, 2002), and John O'Shaughnessy, *The Marketing Power of Emotion* (New York: Oxford University Press, 2003).

62. See Walter Benjamin, "News about Flowers (1928)," in *Walter Benjamin: Selected Writings, vol. 2, 1927-1934,* ed. Howard Eiland, Michael W. Jennings, and Gary Smith (Cambridge, Mass.: Belknap Press of Harvard University Press, 1999), 156. This is what Stanley Cavell called the "false or debased perfectionisms" seen everywhere in marketing and

advertising. See Stanley Cavell, *Conditions Handsome and Unhandsome: The Constitution of Emersonian Perfection* (Chicago: University of Chicago Press, 1990), 16.

63. German advertisers took up American psychology of advertising in the first decade of the twentieth century. See especially, Victor Mataja, "Weiters zur Reklametechnik," in *Die Reklame: Eine Untersuchung über Anküdigungswesen und Werbetätigkeit im Geschäftsleben* (Leipzig: Werlag von Duncker and Humbolt, 1910), 311-39.

64. Steven Heller, "Lucian Bernhard: The Master Who Couldn't Draw Straight," in *Graphic Design History,* ed. Steven Heller and Georgette Balance (New York: Allworth Press, 2001), 111.

65. See Jacques Lacan, "The Mirror Stage as Formative of the Function of I," in *Ecrits: A Selection* (New York: W. W. Norton, 1977), 2-7. Also see Kaja Silverman, *The Threshold of the Visible World* (New York: Routledge, 1996), 12-20.

66. Silverman 1996, 40-41.

67. Silverman 1996, 44.

68. For Lacan's accounts of misrecognition or *"méconnaissance,"* see Jacques Lacan, *The Seminar, Book 1: Freud's Papers on Technique, 1953-54,* trans. John Forrester (New York: W. W. Norton, 1988), 167.

69. Forty 1986, 156.

70. Forty 1986, 157.

71. See Mary Douglas, *Purity and Danger; an Analysis of Concepts of Pollution and Taboo* (New York: Praeger, 1966), 146-47.

72. Forty 1986, 161.

73. Roland Marchand, *Advertising the American Dream: Making Way for Modernity, 1920-1940* (Berkeley: University of California Press, 1985), 219.

74. Nancy Tomes, "Spreading the Germ Theory: Sanitary Science and Home Economics, 1880-1930," in *Woman and Health in America: Historical Readings,* ed. Judith Walzer Leavitt (Madison: University of Wisconsin Press, 1999), 596.

75. Douglas 1966, 146-47.

76. Tomes 199, 607.

77. Gwendolyn Wright has concluded that the relationship between the color white and hygiene was established within American popular culture as early as 1900. See Wright, *Moralism and the Model Home: Domestic Architecture and Cultural Conflict in Chicago, 1873-1913* (Chicago: University of Chicago Press, 1980), 117-20.

78. The defining texts are Catherine E. Beecher and Harriet Beecher Stowe, *The American Woman's Home, or Principles of Domestic Science Being a Guide to the Formation and Maintenance of Economical, Healthful, Beautiful, and Christian Homes* (New York: J. B. Ford, 1869); Christine Frederick, *The New Housekeeping; Efficiency Studies in Home Management* (Garden City, N.Y.: Doubleday, Page and Company, 1913); and Mary Pattison, *Domestic Engineering: Or the What, Why, and How of a Home* (New York: Trow Press, 1915). For an early and somewhat problematic account of the history of the rationalization of the domestic sphere, see Sigfried Giedion, *Mechanization Takes Command: A Contribution to Anonymous History* (New York: Oxford University Press, 1948). The history of the scientization of the

home is covered in Wright 1980 and Wright, *Building the Dream: A Social History of Housing in America* (New York: Pantheon Books, 1981); Glenna Matthews, *"Just a Housewife": The Rise and Fall of Domesticity in America* (New York: Oxford University Press, 1987); Kathleen Anne McHugh, *American Domesticity: From How-to Manual to Hollywood Melodrama* (New York: Oxford University Press, 1999); and Sarah A. Leavitt, *From Catherine Beecher to Martha Stewart: A Cultural History of Domestic Advice* (Chapel Hill: University of North Carolina Press, 2002).

79. See Leavitt 2002.

80. Michael J. Golec, *"Martha Stewart Living* and the Marketing of Emersonian Perfectionism," *Home Cultures* 3, no. 1 (March 2006): 5–20.

81. Wilfred M. McClay, *The Masterless: Self and Society in Modern America* (Chapel Hill: University of North Carolina Press, 1994), 234.

82. The Eisenhower administration stressed the importance of technology and science as means to enhance the quality of American society. James Killian, Jr., special assistant to the president for science and technology, believed that science and technology encouraged "individuality in the midst of standardization, which enhance man's excellence and dignity as well as his productivity." See James R. Killian, Jr., "Science and Public Policy," *Science* 129, no. 3342 (January 16, 1959): 136. The all-pervasive impact of new technologies—literally from the kitchen to the moon—resulted in a far more "contained" culture, where freedoms were curtailed by cold-war anxieties in the United States. For example, see Paul N. Edwards, *The Closed World: Computers and the Politics of Discourse in Cold War America* (Cambridge, Mass.: MIT Press, 1996).

ARCHIVE 3: ART (PP. 83–116)

1. Christine J. Mamiya, *Pop Art and Consumer Culture: American Super Market* (Austin: University of Texas Press, 1992); Cécile Whiting, *A Taste for Pop: Pop Art, Gender, and Consumer Culture* (New York: Cambridge University Press, 1997); and Thomas Crow, *The Rise of the Sixties: American and European Art in the Era of Dissent* (New York: Harry N. Abrams, 1996).

2. Henri Lefebvre, *Everyday Life in the Modern World* (New Brunswick, N.J.: Transaction Publishers, 1984), 90.

3. Pat Hackett and Andy Warhol, *POPism: The Warhol '60s* (New York: Harcourt Brace Jovanovich, 1980), 3.

4. Andy Warhol, *The Philosophy of Andy Warhol (From A to B and Back Again)* (New York: Harcourt, Brace and Company, 1975), 93.

5. Hackett and Warhol 1980, 4.

6. Joseph Kosuth, *Art after Philosophy and After: Collected Writing, 1966–1990* (Cambridge, Mass.: MIT Press, 1991), 117, 119.

7. I take this idea of "embodiment" from Jules David Prown, "Mind in Matter: An Introduction to Material Culture Theory and Method," *Winterthur Portfolio* 17, no. 1 (spring 1982): 1.

8. Benjamin H. D. Buchloh, "Andy Warhol's One-Dimensional Art: 1956–1966," in *Andy Warhol,* ed. Annette Michelson (Cambridge, Mass.: MIT Press, 2001), 13–14. Buchloh's article

was originally published in the exhibition catalog *Andy Warhol: A Retrospective,* ed. Kynaston McShine (New York: Museum of Modern Art, 1989).

9. Ibid., 14.

10. On the lasting influence of positivist efforts to organize human activities and environments in the postwar era, see Reinhold Martin, *The Organizational Complex: Architecture, Media, and Corporate Space* (Cambridge, Mass.: MIT Press, 2003). For a discussion of the disciplining tendencies of the diagram in Frank and Lillian Gilbreth's "scientific management," see Hyungmin Pai, *The Portfolio and the Diagram: Architecture, Discourse, and Modernity in America* (Cambridge, Mass.: MIT Press, 2002), 162–75.

11. David Deitcher, "Unsentimental Education: The Professionalization of the American Artist," in *Hand-Painted Pop: American Art in Transition, 1955–1962,* ed. Russell Ferguson (Los Angeles: Museum of Contemporary Art, 1992), 101. Deitcher quotes from Lepper, "Process in Professor Lepper's Courses in Pictorial Design, August 1948," Lepper Collection, Carnegie Mellon University Archives, pp. 1–6. Deitcher quotes Lepper to substantiate his claim that Warhol had been influenced by Bauhaus-inspired ideals. Lepper had disputed the influence of Bauhaus pedagogy on his "'pictorial' group" of students, of whom Warhol had been one. See Lepper to Rainer Crone, January 1974, Lepper Collection. Lepper assumed, however, that, whether or not he had drawn explicitly from Bauhaus material, his courses were in keeping with a Bauhaus discourse established by Moholy-Nagy before World War II and Kepes in the immediate postwar era. See especially his extensive notes on Kepes's *Language of Vision* in the Robert L. Lepper Collection, Carnegie Mellon University Library, Pittsburgh, Pa., and Richard Guy Wilson, "Robert Lepper and the Machine Age," *Carnegie Magazine,* May–June 1987, 12–19.

12. Lepper Collection.

13. Warhol admitted to seeking psychiatric help to, in his words, "define some of my own problems." See Warhol 1975, 21. Anecdotal evidence has suggested that Warhol may have been aware of criticisms of psychology. Warhol reported that he declined an invitation to take an IQ test administered by a clinical psychologist. See Warhol and Hackett 1989, 133. Also see Victor Bockris, *The Life and Death of Andy Warhol* (New York: Bantam, 1998), 96, and Victor Bockris, *Warhol* (Cambridge, Mass.: Da Capo Press, 2003), 134.

14. For a history of the Rorschach technique as it was developed by the Swiss psychologist Hermann Rorschach and its reception in the United States, see James M. Wood, *What's Wrong with the Rorschach?: Science Confronts the Controversial Inkblot Test* (San Francisco: Jossey-Bass, 2003).

15. See Archive 1. Also see Ludwig Wittgenstein, *Philosophical Investigations,* trans. G. E. M. Anscombe (Oxford: Blackwell, 1953), 153.

16. See the introduction. Also see Wittgenstein 1953, 178.

17. Michel Foucault, *The Archaeology of Knowledge* (New York: Pantheon Books, 1972), 40. Also see Michel Foucault, *Madness and Civilization: A History of Insanity in the Age of Reason* (New York: Random House, 1965).

18. Discussing this exhibition, Rosalind Krauss observes that Warhol's paintings refer to Pollock's "drip" paintings and Morris Louis's "stain" paintings. "But by folding the stain technique into the Rorschach formula, Warhol pulls the plug on these aspirations to sublima-

tion by reminding us that there is no form so 'innocent' (or abstract) that it can ever avoid the corruption of a projective interpretation, a 'seeing-in' or a 'seeing-as.'" It should be noted that viewers cannot really see Warhol's paintings as Pollock's or Louis's paintings, but they can certainly see Pollock and Louis paintings in Warhol's Rorschach paintings. See Rosalind Krauss, "Carnal Knowledge," in *Andy Warhol: Rorschach Paintings* (New York: Gagosian Gallery, 1996), 7-8.

19. Bockris 2003, 24.

20. See Bennard B. Perlman, "The Education of Andy Warhol," in *The Andy Warhol Museum* (Pittsburgh: Andy Warhol Museum, 1994), 147-51. While others have commented on Warhol's education, none have offered as much detail as Perlman does. For an informative but less thorough account of Warhol's Carnegie Tech years, see Rainer Crone, *Andy Warhol,* trans. John William Gabriel (London: Thames and Hudson, 1970), 12.

21. Perlman 1994, 162.

22. Ibid.

23. The practice of participant observation is a hallmark of traditional cultural anthropology. The term describes full cultural immersion as a method of field research. In Warhol's case, the traditional problem of the relationship between subjective experience and objective observation in participant observation was further confused since he was the focus of his own study. For a discussion on the problematics of participant observation, see James Clifford, "Introduction: Partial Truths," in *Writing Culture: The Poetics and Politics of Ethnography,* ed. James Clifford and George E. Marcus (Berkeley: University of California Press, 1986), 13-14.

24. Ruth Benedict, *Patterns of Culture* (New York: Houghton Mifflin, 1934).

25. Christina Cogdel, *Eugenic Design: Streamlining America in the 1930s* (Philadelphia: University of Pennsylvania Press, 2004), 196-97.

26. David Green, "Veins of Resemblance: Photography and Eugenics," *The Oxford Art Journal* 7, no. 2 (1985): 4.

27. Benedict 1934, 48.

28. Ibid., 55.

29. Ibid.

30. See especially her chapter "The Individual and Pattern of Culture," 251-78. Also see Ruth Benedict, "Culture and the Abnormal," *Journal of General Psychology* 1 (1934): 60-64.

31. Benedict 1934, 245. Also see Richard Handler, "Vigorous Male and Aspiring Female: Poetry, Personality, and Culture in Edward Sapir and Ruth Benedict," in *Malinowski, Rivers, Benedict, and Others: Essays on Culture and Personality,* ed. George W. Stocking (Madison: University of Wisconsin Press, 1986), 149-50.

32. Herbert Marcuse, *Eros and Civilization: A Philosophical Inquiry into Freud* (Boston: Beacon Press, 1955), 223.

33. Karl Marx, *The Eighteenth Brumaire of Louis Bonaparte* (Moscow: Progress Publishers, 1967), sec. 7, and Gyorgy Lukács, *History and Class Consciousness: Studies in Marxist Dialectics* (Cambridge, Mass.: MIT Press, 1971), 50-51.

34. Meyer Schapiro, "Courbet and Popular Imagery: An Essay on Realism and Naiveté

(1941)," in *Nineteenth and Twentieth Centuries: Selected Papers* (New York: George Braziller, 1978), 65.

35. Warhol's parents, Ondrej and Julia Warhola, immigrated to the United States from the Ruthenian village of Mikova, near the borders of Russia and Poland. Bockris 2003, 15-16.

36. See Georg Frei and Neil Printz, eds., *The Andy Warhol Catalogue Raisonné,* vol. 1: *Paintings and Sculpture, 1961-1963* (London: Phaidon Press, 2002), 101.

37. For a thorough account of Pop Art's transition from semi-expressive handling of subject matter to more mechanical techniques of reproduction and representation, see the essays included in Ferguson 1992.

38. On modernism's negation and resistance, see T. J. Clark, "Clement Greenberg's Theory of Art," in *Pollock and After: The Critical Debate,* ed. Francis Frascina (New York: Harper and Row, 1985), 52-53.

39. The popular dances were the twist, the frug, the watusi, the jerk, the mashed potato, the funky chicken, the Freddie, and the swim. The names of these dances and the dances themselves were designed to distinguish the culture of 1960s youth from the culture of the previous generation. Edward J. Reilly, *The 1960s, American Popular Culture through History* (Westport, Conn.: Greenwood Press, 2003), 202.

40. Perlman has claimed that this passage "in particular appealed to Andy." Perlman 1994, 163. Also see Benedict 1934, 273: "Much more deviation is allowed to the individual in some cultures than in others, and those in which much is allowed cannot be shown to suffer from their peculiarity."

41. More work needs to be done here, especially in response to scholarship on issues relating to the potential and development of an ongoing "history of identificatory relations" with certain objects and images of male homosexuality. See Whitney Davis, " 'Homosexualism,': Gay and Lesbian Studies, and Queer Theory in Art History," in *The Subjects of Art History: Historical Objects in Contemporary Perspective,* ed. Mark A. Cheetham, Michael Ann Holly, and Keith Moxey (Cambridge: Cambridge University Press, 1998). For the nascent stages of queer research in Warhol studies, see Jennifer Doyle, Jonathan Flatley, and José Esteban, eds., *Pop Out: Queer Warhol* (Durham: Duke University Press, 1996); Michael Lobel, "Warhol's Closet," *Art Journal* (winter 1996): 42-50; Deborah Bright, "Shopping the Leftovers: Warhol's Collecting Strategies in *Raid the Icebox I,*" in *Other Objects of Desire: Collectors and Collecting Queerly,* ed. Michael Camille and Adrian Rifkin (Oxford: Blackwell, 2001); and Bradford R. Collins, "Dick Tracy and the Case of Warhol's Closet: A Psychoanalytic Detective Story," *American Art* 15, no. 3 (autumn 2001): 54-79.

42. The dance diagrams were the only paintings that Warhol installed on the floor. But, as Krauss explains, they were not the only artworks intended as such. Warhol intended his *Oxidation Paintings* (or *Piss Paintings*) from 1977 to have the same orientation. See Rosalind E. Krauss, *The Optical Unconscious* (Cambridge, Mass.: MIT Press, 1993), 270.

43. Ibid., 245. The critical text on the radicality of the horizontal orientation of visual art is Leo Steinberg, *Other Criteria* (New York: Oxford University Press, 1972). In this important text, Steinberg introduced his concept of the "flatbed picture plane" in Robert Rauschenberg's work.

44. Francis V. O'Conner, "Hans Namuth's Photographs of Jackson Pollock as Art Historical Documentation," *Art Journal* 39, no. 1 (fall 1979): 48.

45. Ibid.

46. Krauss made this connection by raising the issue of Pollock's celebrity and Warhol's obsession with fame, the latter being influenced by the former. Krauss 1993, 275. Warhol admitted to his fascination with Pollock's celebrity in Warhol and Hackett 1980, 13–15. Also, Pepe Karmel has attempted to recover the proper sequence of lines hitting canvas in Pollock's paintings. Karmel used still frames taken from Namuth's film in order to examine Pollock's process. Most interesting are composite still images taken from successive frames of Namuth's film of Pollock painting, which underscored the painter's "dance"-like movements around and on the canvas. See Pepe Karmel, "Pollock at Work: The Films and Photographs of Hans Namuth," in *Jackson Pollock,* ed. David Frankel, with Harriet Bee and Jasmine Moorhead (New York: Museum of Modern Art, 1999).

47. Laszlo Moholy-Nagy, *Vision in Motion* (Chicago: Paul Theobald, 1947), 122. Also see Lepper to Rainer Crone, January 1974, Lepper Collection.

48. On the status of "Warhol Studies," see Branden W. Joseph, "One-Dimensional Man," *Art Journal* 57, no. 4 (winter 1998): 105–9.

49. The controversy was reported in the September 1963 issues of *Art News* and *Artforum.* In two separate but near identical-articles, Loran took issue with the artist Roy Lichtenstein and the Pop artist's alleged plagiarism. See Erle Loran, "Pop Artists or Copy Cats?" *Art News* 62, no. 5 (1963): 48–49, 61, and Erle Loran, "Cezanne and Lichtenstein: Problem of Transformation," *Artforum* 2, no. 3 (September 1963): 34–35. Michael Lobel has performed the most thorough evaluation of the controversy. See Lobel, *Image Duplicator: Roy Lichtenstein and the Emergence of Pop Art* (New Haven: Yale University Press, 2002), 110–11.

50. Warhol's boxes were exhibited in a variety of locations. For example, in 1964 the boxes were also exhibited at Leo Castelli, and they were shown as part of *Art in Wood Today,* a group exhibition at the United States Plywood Building, New York City. In 1965, several boxes were included in a Warhol retrospective at the Institute of Contemporary Art, Philadelphia. In 1966, the *Brillo* boxes were included in a Warhol retrospective at the Institute of Contemporary Art, Boston.

51. Photographs of supermarket shelving found in Warhol's archive reveal his interest in retail display and its affective properties. See Frei and Printz 2002, 32.

52. Andy Warhol in Glenn O'Brien, "Interview: Andy Warhol," *High Times* 24 (August 1977): 34.

53. Tom Wesselmann's *Still Life #17* (1962) includes a BRILLO® box. The painting was also exhibited in the New Realists show at the Sidney Janis Gallery.

54. Gluck quoted in Patrick S. Smith, *Andy Warhol's Art and Films* (Ann Arbor: UMI Research Press, 1986), 169.

55. Original box templates, film positives, and photographs that document Warhol's box production are in the Archives Study Center, Andy Warhol Museum, Pittsburgh, Pa. The process of photoreproduction prior to application of the silk screen to canvas has not been discussed in the literature on Warhol. My thanks to Matthew Wrbican, archivist at the Andy Warhol Museum, for making the original boxes and negatives available to me.

56. Hal Foster, "Death in America," *October* 75 (winter 1996): 43. Also see Hal Foster, *The Return of the Real* (Cambridge, Mass.: MIT Press, 1996), and "Death in America," in *Who Is Andy Warhol,* ed. Colin McCabe with Mark Francis and Peter Wollen (London and Pittsburgh: British Film Institute and Andy Warhol Museum, 1997), 117-30.

57. Annette Michelson, "'Where Is Your Rupture?': Mass Culture and the Gesamtkunstwerk," *October* 56 (spring 1991), 46. I use "mediating" cautiously here. Nevertheless, I take the body as the ground for an ongoing battle between enjoyment and suffering, both of which are modes of accumulation in Marcuse's sense.

58. Ibid., 62.

59. Ibid. Also see Max Horkheimer and Theodor W. Adorno, *Dialectic of Enlightenment,* trans. John Cumming (New York: Seabury Press, 1972), 236.

60. Ibid.

61. Immanuel Kant, *Critique of Judgment,* trans. Werner S. Pluhar (Indianapolis: Hackett Publishing, 1987), sec. 29.

62. Peter Selz, "The Flaccid Art," *Partisan Review* (summer 1963), 315.

63. See Theodor W. Adorno, *Minima Moralia: Reflections from Damaged Life* (New York: Verso, 1996).

64. Marcuse 1955, 210, and Norman O. Brown *Life Against Death: The Psychoanalytical Meaning of History* (Middletown, Conn.: Wesleyan University Press, 1959), 21.

65. Thomas Crow, "Modernism and Mass Culture in the Visual Arts," in Frascina 1985, 238.

66. The Stable Gallery exhibition was an early instance of this activity. As Deborah Bright has observed, Warhol's *Raid the Icebox* exhibition at the Rhode Island School of Design in 1969 was yet another instance. See Bright 2001, 116-29.

CONCLUSION (119-25)

1. According to Venturi and Scott Brown, the decorated shed is a conventional shelter with "applied" symbols. This is in opposition to the sculptural "duck" so common in orthodox modernist architecture. See Robert Venturi, Denise Scott Brown, and Steven Izenour, *Learning from Las Vegas: The Forgotten Symbolism of Architectural Form* (Cambridge, Mass.: MIT Press, 1977), 87-91.

2. See Douglas Crimp, *On the Museum's Ruins* (Cambridge, Mass.: MIT Press, 1993).

3. G. R. Swenson, "The Personality of the Artist" exhibition announcement, Stable Gallery, 1964, Archives Study Center, Andy Warhol Museum, Pittsburgh, Pa. Sinclair emphasizes the effect of the ambient environment on feelings as instances of knowledge gathering in the empirical sense of "knowing." See William Angus Sinclair, *The Conditions of Knowing: An Essay Towards a Theory of Knowledge* (London: Routledge and Kegan Paul, 1951), 158-63.

4. See Nelson Goodman, *Of Mind and Other Matters* (Cambridge, Mass.: Harvard University Press, 1984), 55.

5. Pat Hackett and Andy Warhol, *POPism: The Warhol '60s* (New York: Harcourt Brace Jovanovich, 1980), 4.

INDEX